IMAGES
of America

THE COLONIAL
PARKWAY

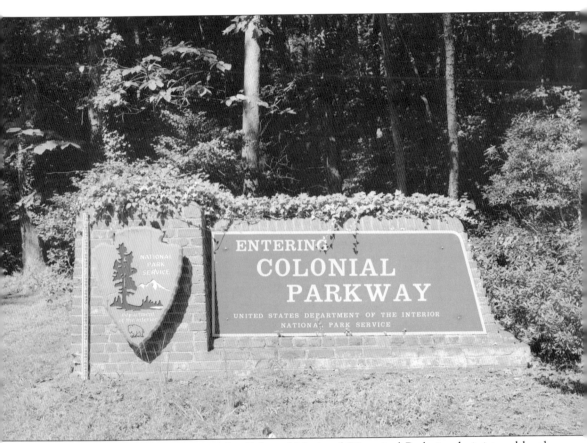

The Colonial Parkway, part of the Colonial National Historical Park, is administered by the National Park Service. The roadway allows visitors to drive from Jamestown's historic area past Colonial Williamsburg and follow the York River to Yorktown, scene of the battle that ended the American Revolution. As visitors travel the parkway, they experience a tranquil drive back in time along rivers and ponds where they can enjoy historic overlooks, fishing, walks, and beaches. (National Park Service, Colonial National Historical Park.)

ON THE COVER: The Colonial Parkway tunnel was constructed to direct traffic under Colonial Williamsburg, preserving the historic area's existing buildings and land while offering parkway drivers the option to either continue along the scenic route or use one of several exit ramps to access the historic area. The cover picture shows the construction of the tunnel as it passed beneath Duke of Gloucester Street. To the right is the restored courthouse, and in the background stands one of the old buildings of Eastern State Hospital. Eastern State began in 1773 as the first public psychiatric hospital in North America. (National Park Service, Colonial National Historical Park.)

IMAGES
of America

THE COLONIAL
PARKWAY

Frances Watson Clark

ARCADIA
PUBLISHING

Published by Arcadia Publishing
Charleston SC, Chicago IL, Portsmouth NH, San Francisco CA

Printed in the United States of America

Library of Congress Control Number: 2009940081

For all general information contact Arcadia Publishing at:
Telephone 843-853-2070
Fax 843-853-0044
E-mail sales@arcadiapublishing.com
For customer service and orders:
Toll-Free 1-888-313-2665

Visit us on the Internet at www.arcadiapublishing.com

*To my husband Chris, whose support, encouragement, and
love have kept me focused, successful, and happy.*

CONTENTS

ACKNOWLEDGMENTS

The Colonial Parkway has been obliquely referenced in books about Virginia's Historic Triangle region and has been the subject of short articles, but it has never had a book of its own. My first call was to Mike Litterst, public affairs officer for the Colonial National Historical Park in Yorktown. Mike was extremely helpful. Without his assistance, this book would not exist.

I also wish to thank James Perry, Melanie Pereira, and Karen Rehm of the Colonial National Historical Park for their help with information and pictures. Lee Walker of the Virginia Department of Game and Inland Fisheries was extremely accommodating in providing wildlife pictures. Thanks go to Jean Bruce of Williamsburg for the use of her 1949 William and Mary yearbook. I would like to express my appreciation to Jim Kelly who shared his college stories, to Allen and Mary Turnbull for sharing their pictures of the "Pedal the Parkway" event, and to Steve Bolt for his photographs taken during the Richmond Area Bicycling Association event.

Editor Rusty Carter and publisher Bill O'Donovan of the *Virginia Gazette* were invaluable in telling me where to find information and who to call, while Robbie Steele assisted with photographs and information. Battalion Chief Thomas R. Banks of the Williamsburg Fire Department shared several pictures of assistance the department gave on the parkway.

Mark Piggott, public affairs officer at the Yorktown Naval Weapons Station, was tremendous in getting me photos and information about historic events at the weapons station and Cheatham Annex.

Marianne Martin, visual resources librarian for the Colonial Williamsburg Foundation, was a great resource in supplying pictures.

Will Molineux was exceptional for his knowledge of the area, his willingness to help with photos, and his love of history.

As far as time and assistance, Rosanne Butler, director of the Archives and Records, Department of Colonial Williamsburg Foundation, and Mary Ann Goode, department secretary, were incredible. They found exactly what I needed and more.

I want to thank Betty Price, daughter of Paul Griesenauer, for her kindness to share her father's story and pictures with me. I appreciate Dr. George W. Grayson in sharing his story of walking the parkway back in 1971 for his campaign.

Bobbie Hair Grainger of the Jamestown-Yorktown Foundation was instrumental in assisting me with my research and picture requests.

Special thanks to my editor, Elizabeth Bray, for giving me guidance, pushing me when I needed it, and giving me the time to get it right.

Thanks to the Colonial Williamsburg Foundation (CWF), the Library of Congress (LOC), and the National Park Service (NPS) for their help with images.

I would also like to recognize my cousin Jay Stewart. He is amazing at finding information on the Internet that no one else can.

I would also like to thank my children, Katherine and Philip, for their love and support.

INTRODUCTION

In the early 1920s, Williamsburg and Yorktown were sleepy little Virginia towns forgotten by most for their historic significance in the birth of America. Though some preservation of Jamestown Island had begun in the late 1800s with the acquisition of land by the Association for the Preservation of Virginia Antiquities (APVA, now known as Preservation Virginia), Jamestown mainly consisted of a few, uninterpreted Colonial-era ruins and several houses in which people lived quiet lives. All this began to change when John D. Rockefeller Jr. came to Williamsburg and was courted and convinced by Rev. Dr. William Archer Rutherefoord (W. A. R.) Goodwin, rector of historic Bruton Parish Church, to begin the preservation and restoration of what was once Colonial Virginia's capital city. As the restoration got underway, the work in Williamsburg inspired others, who began looking at other local areas of interest. Virginia's governor, Harry Flood Byrd, worked with William Carson, director of the Virginia Commission on Conservation and Development, to try to increase Virginia tourism.

Two key NPS officials, Stephen Mather (first NPS director) and Horace Albright (his assistant and future NPS director) nearly visited Yorktown before 1916 at the suggestion of Cincinnati judge Howard Ferris, a former classmate of Mather. Ferris owned land there and thought the area would make a wonderful park or monument. Mather and Albright headed to Yorktown to look over the area, but car trouble made them turn around. Another decade would slip away before either man visited the area.

Finally in 1929, Albright—at Carson and Rockefeller's invitation—came to tour Richmond, Williamsburg, Jamestown, and Yorktown. He also met many influential people such as Gov. John G. Pollard, several former Virginia governors, Rev. Dr. W. A. R. Goodwin, the ladies of the APVA, and Rep. Louis C. Cramton of Michigan. A strong proponent of developing the historic sites, Cramton was also very influential in Congress. It was on this visit that all of the above parties decided that a Colonial National Monument would be a great asset to both the area and the nation. The groundwork was set for a scenic road that would connect Jamestown, Williamsburg, and Yorktown.

Land would have to be acquired. Historic buildings would have to be purchased and restored. All of this would take extensive planning and the approval of Congress. The group decided that the influential Cramton should sponsor the legislation. With the support of Virginia leaders, Rockefeller's group, the NPS, and the APVA, Cramton was able to get the legislation passed. Pres. Herbert Hoover signed the proclamation establishing the Colonial National Monument, including the parkway, on July 3, 1930, and the NPS began to acquire historic lands and properties in Yorktown and Jamestown.

The original path for the parkway would have followed the Colonial-era roads away from the rivers. However, after doing extensive surveys and reviewing aerial pictures, NPS architect Charles E. Peterson and NPS engineer Oliver G. Taylor decided that the route should follow the York River in Yorktown and the James River near Jamestown. This was Peterson's first major assignment; he designed the parkway and helped with the completion of its first stage.

Work began in 1931 on what eventually would become 23 miles of a road unlike any other. The architects followed the style used for other NPS parkways such as Mount Vernon Memorial Highway. The route would follow along the York River on property owned by the U.S. Navy.

Once rights-of-way were obtained, construction began. The work done during the Depression caused no issues for the construction of the parkway, and if anything, the Civilian Conservation Corps (CCC) labor actually was one of the reasons the work from Yorktown to Williamsburg was completed as quickly as it was.

The next hurdle would be getting through Williamsburg. The restoration of Virginia's one-time capital had already begun, and many opposed the idea of running a parkway through the middle of town. One proposed alternative would drive the road through Rockefeller's property; another would avoid Williamsburg altogether. Rev. Dr. W. A. R. Goodwin proposed the tunnel route under the historic area and argued persuasively for its benefits. A tunnel through town, he said, would actually be less costly than a long, winding road around it and be less destructive to the area's beauty and Colonial atmosphere than a parkway *through* the city—while still preserving the considerable potential economic benefits to Williamsburg of having all those vacationing tourists pass through town. Finally, after much debate, Rev. Dr. Goodwin's arguments won the day: a tunnel would be created, and the route would pass beneath Colonial Williamsburg.

The tunnel was completed in 1942 with the exception of the paving of the tunnel and the roads on either side of the entrances. The advent of World War II, however, meant a diversion of funds and manpower to the war effort. The Williamsburg tunnel was not opened to the public until 1949.

The final leg of the parkway was begun in the early 1950s and completed in 1957, in time for the 350th anniversary of the founding of Jamestown. That year, England's Queen Elizabeth II came to the celebration and was driven to Jamestown on the newly completed parkway. (She would make the same trip 50 years later for Jamestown's 400th anniversary in 2007.)

Today the Colonial Parkway is truly an architectural marvel—a sort of paved time line through America's Colonial period, linking three distinct and historically important communities with a route unmarred by modern roadside development and billboards. This time line begins in Jamestown, the site of the first permanent English colony in North America. Next it proceeds through Williamsburg, where those colonists and their descendants formed a capital and a government defiant of British rule. Travelers then finish the final leg of this time line at Yorktown, where colonists (and their French allies) fought and won their independence from England.

The parkway is a place where children and adults can learn about America's past as well as simply enjoying the chance to bike, fish, and sunbathe in pristine Tidewater countryside. The beautiful, fertile lands that gave birth to America have also produced an abundance of distinctive flora and fauna.

The credit for this scenic byway goes to the men and women of the NPS, and of Williamsburg, Yorktown, and Jamestown, whose dedication, vision, and determination made it possible for the Colonial Parkway to exist and endure over the years. Their devotion to historical research and preservation continues to benefit all those who seek a glimpse into the past.

One

BEFORE THE PARKWAY

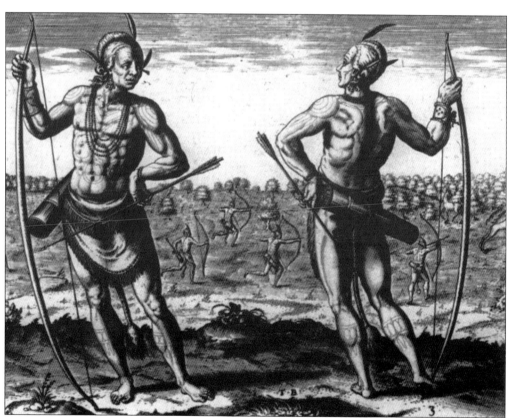

When the first English settlers arrived in Virginia, Native Americans had lived between the York and the James Rivers for some 10,000 years. Agriculture was their main food source; women and children tended a village's corn, squash, gourd, bean, nut, and grain crops. Men hunted and trapped deer, bears, fish, and other game. This late-1500s engraving by Flemish printer Theodore de Bry (based on watercolor portraits by Roanoke Island colonist John White) depicts two tattooed Native American hunters in the foreground. (LOC.)

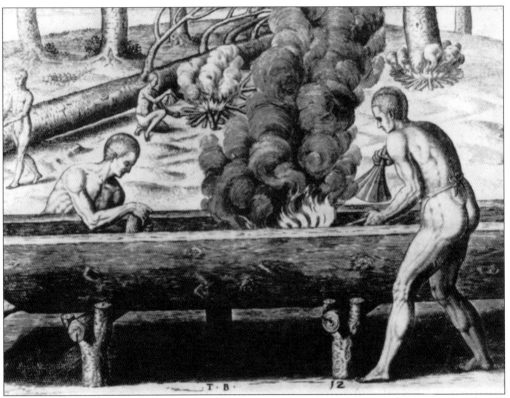

In the spring, the Powhatan, Chickahominy, and Pasbehay Indians fished the James and York Rivers in canoes made of logs hollowed-out with fire and hand tools. (LOC.)

In 1607, Jamestown Island became home to the first permanent English settlement in the New World. This picture was taken on September 2, 1920, from an airship. The Yeardly House sits at the island's lower left-hand corner and the 103-foot Tercentennial obelisk stands to the right. (National Park Service, Colonial National Historical Park.)

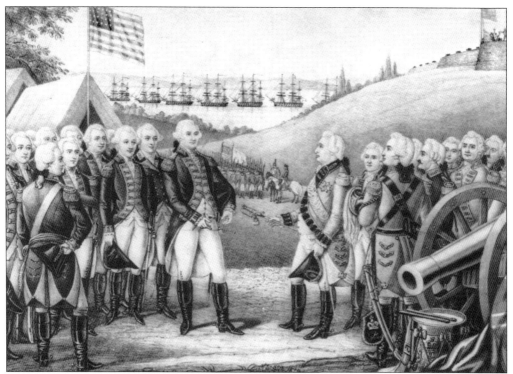

On October 19, 1781, the American Revolution effectively ended at Yorktown. With French ships blockading the Chesapeake—preventing British ships from evacuating or resupplying Gen. Charles Cornwallis's army at Yorktown—American and French troops under Gen. George Washington and the Comte de Rochambeau laid siege to the town. The British soon surrendered. In this drawing, Cornwallis is shown humbly requesting terms of capitulation from Washington. In reality, neither man was present at the surrender. Feigning illness, Cornwallis sent Brig. Gen. Charles O'Hara to capitulate in his stead. Refusing to meet with his adversary's subordinate, Washington directed O'Hara to surrender to his own second-in-command, Maj. Gen. Benjamin Lincoln. (LOC.)

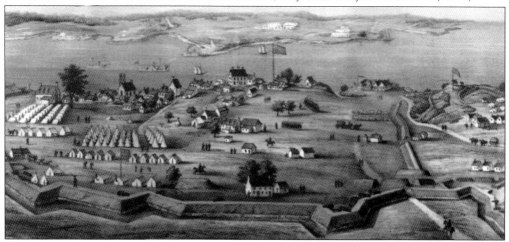

Yorktown was a shipping port almost from its beginning and in 1634 became a shire known as Charles River Shire. It was established as Yorktown in 1691. The top product shipped from its wharves was tobacco, the most profitable commodity of the day. (LOC.)

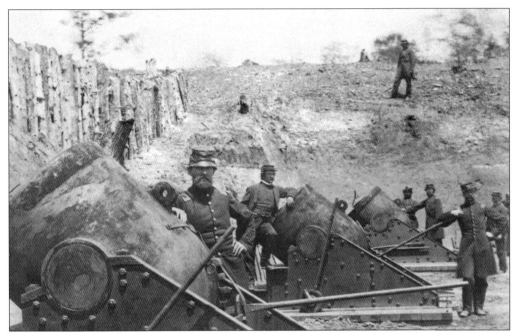

In 1862, Union major general George McClellan wanted to reach Richmond and felt that the Virginia peninsula was the best way get there. McClellan's troops surrounded Yorktown and Confederate major general John Bankhead Magruder's Army of the Peninsula, which had retreated inside the town's defensive works. A month-long siege ensued. Finally Magruder's men retreated, and the Northerners swept over their abandoned works and into Yorktown itself. The Union would occupy the town for the rest of the war. In this image, Federal soldiers are shown manning Union Battery No. 4, located at what is today the Coast Guard Training Center. (LOC.)

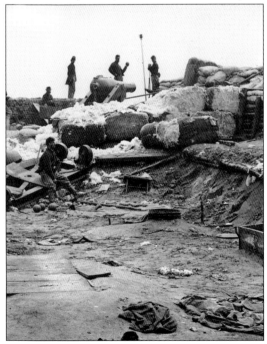

Here eight soldiers sandbagged (and cotton-baled) cannon replacements; another soldier (mid-ground) is seated on what looks like an upended cannon carriage. The site of skirmishes and a large-scale siege, Yorktown played a dramatic role in the Civil War, just as it had in the American Revolution. (LOC.)

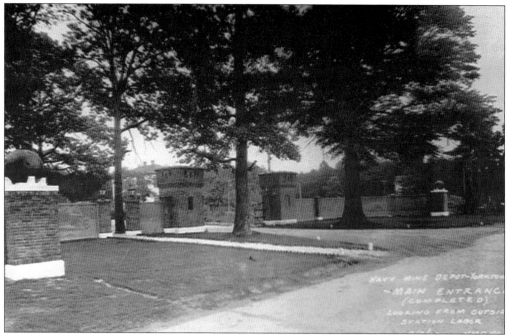

In 1917, before the Colonial Parkway was built, the U.S. Mine Depot was established along the York River. The U.S. government needed a place to store weapons, and the site selected for this needed to meet two criteria: it must have deep water for the ships that would deliver and remove ordnance from the fort, and it must be a large enough area to provide a buffer around the depot itself, in the interests of both safety and security. One of the early main entrances to the Mine Depot is seen here in 1922. (U.S. Navy.)

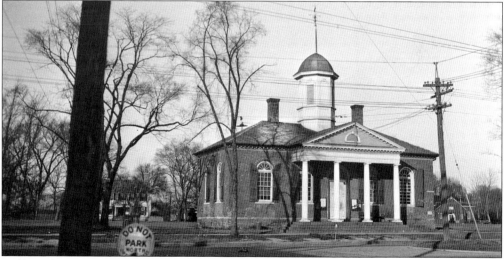

Williamsburg served as Virginia's capital from 1699 until 1780. The courthouse served both Williamsburg and James City County. In 1776, from its steps, the Declaration of Independence was read aloud to rally the colonists to the Patriot cause. The building served as a Confederate hospital during the Civil War. After a 1911 fire, the courthouse was rebuilt with the addition of the columns seen here. However, when the courthouse was restored to its 18th-century appearance, the columns were removed, and it became known as the courthouse of 1770. (LOC.)

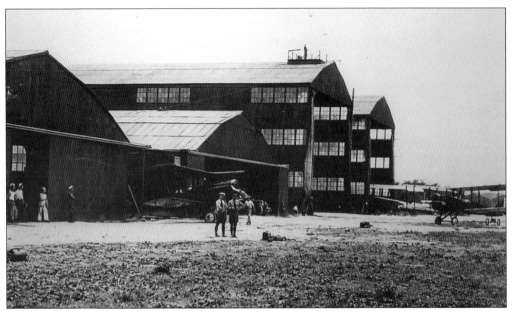

The Aviation Training School was established at the depot after World War I, providing pilots a place to practice naval bombing, torpedo, and gunnery operations. (U.S. Navy.)

After World War I, the U.S. Navy shipped nearly all of its underwater mine stockpile to the new Navy Mine Depot at Yorktown. The mines were kept in open fields while workers built proper storage facilities. Mounted U.S. Marine guards provided security for the area until 1960, when motorized vehicles finally replaced the horses. (U.S. Navy.)

Two

CREATION AND DEVELOPMENT OF THE PARKWAY

Horace M. Albright, second director of the NPS, is pictured here at Yellowstone in 1922. Though the NPS was initially established to preserve natural areas for public use, Albright's vision included historic sites and the development of those sites in such a way that the public might both enjoy and learn from them. He was instrumental in working with other key figures in the Hoover and Roosevelt administrations to obtain the approval of Congress, the public funding for the necessary departments, and the financial support required to complete the parkway. (LOC.)

Virginia politician Harry Flood Byrd was a driving force for tourism in the state. Governor of Virginia from 1926 until 1930, he went on to serve as a U.S. senator from 1933 until 1965. As governor, Byrd worked with Virginia Conservation and Development Commission president William Carson to find ways to increase Virginia tourism. He fully supported the park and parkway projects and sought to provide whatever resources were needed to make them successful. (LOC.)

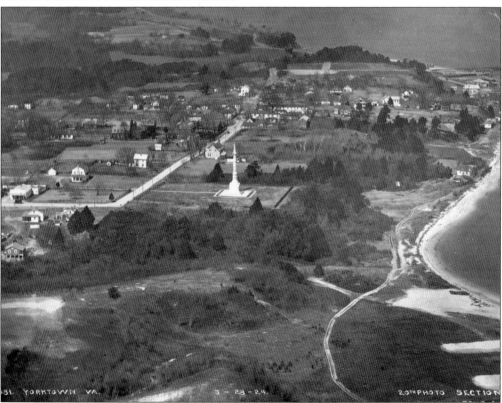

The small seaport of Yorktown was established in 1691 and is the equal of both Jamestown and Williamsburg in its historic importance. In the 17th century, Native American villages and York River plantations bordered Yorktown. This photograph, taken from an Airbus, features the Yorktown Victory Monument. (Williamsburg Fire Department.)

Visionary Stephen T. Mather's love of history and passion to preserve land for public use inspired him to help create the NPS. Mather began his public service career as assistant to the U.S. Secretary of the Interior in 1915. He worked with Horace Albright to gain public and congressional support to create a governmental department with the power to create and maintain a collection of federally owned parks for the use of the American public. In 1916, the NPS was established, and Mather became its first director. In his efforts to expand the NPS's land holdings, he even spent his own personal fortune. During his tenure, the NPS acquired the properties that would become Shenandoah and Great Smoky Mountains National Parks. Forced into retirement by illness, Mather was replaced by Albright. Mather died in 1930. (National Park Service, Colonial National Historical Park.)

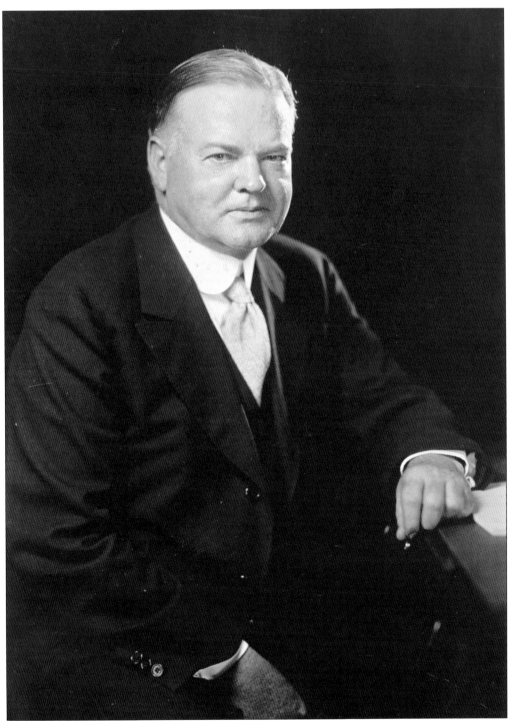

Herbert Hoover, 31st president of the United States, believed strongly in the preservation of historic sites and worked towards this goal with members of the NPS, then still in its infancy. On July 3, 1930, Hoover signed legislation creating the Colonial National Monument and providing for the development of the Colonial Parkway. (National Park Service, Colonial National Historical Park.)

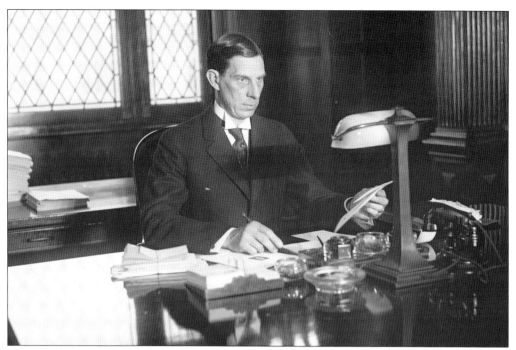

Dr. Ray Lyman Wilbur served as U.S. Secretary of the Interior under President Hoover. He was instrumental in helping to build the NPS, which was still moving forward with acquisitions. President of Stanford University from 1916 until 1943, Wilbur helped get the right-of-way for the Colonial Parkway to be built along the York River on U.S. Navy property. (LOC.)

U.S. Secretary of the Navy Charles Francis Adams, right, stands on the White House lawn beside Nicholas Longworth, speaker of the House of Representatives. Adams served in the Hoover Administration with Ray Wilbur. In 1931, he assisted NPS director Horace Albright in gaining permission for NPS engineers to survey the grounds of the Navy Mine Depot, located along the York River. When the navy afterwards refused to turn over the land to the parkway, Horace Albright brought the proclamation needed to secure the NPS's desired route to Wilbur, who delivered it to President Hoover before the next scheduled cabinet meeting. Without Adams present to raise an objection, Hoover signed the proclamation. By the time Adams found out about it, the route was already set. (LOC.)

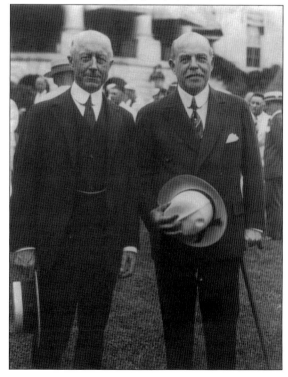

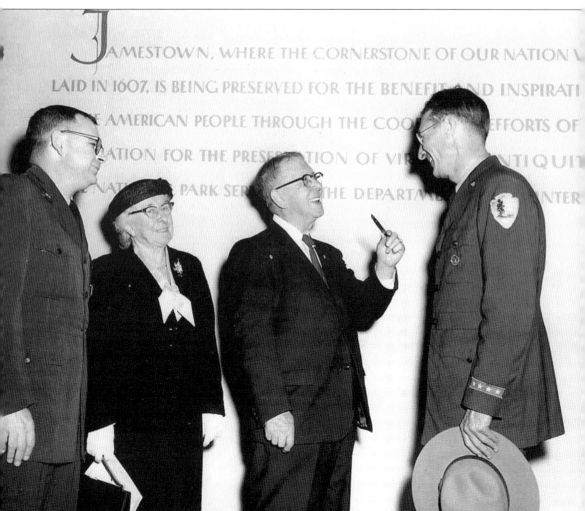

Michigan congressman Louis Cramton supported the idea of a Colonial National Monument early on. Strongly committed to preserving history, Cramton had already supported the creation of other parks when he first visited the area in 1929. He came at the invitation of Gov. Harry F. Byrd and other prominent Virginians, who strongly urged him to sponsor a bill for the park's creation. The Virginians knew that having a non-Virginian propose the bill would make Congress less likely to dismiss the proposal as merely the product of local self-interest. Cramton agreed to introduce the bill, which ended up creating the Colonial National Monument, including a parkway to connect Yorktown, Williamsburg, and Jamestown. Cramton lost in his next election, but he continued in public service as an attorney for the U.S. Department of Interior. Pictured here from left to right are Colonial National Historical Park historian Charles Hach, Alice Cary Cramton, Louis Cramton, and Colonial National Historical Park superintendent Stanley Abbott. Cramton is presenting the pen that was used by President Hoover to sign the proclamation into law in 1930. (National Park Service, Colonial National Historical Park.)

Horace Albright, seen here in his park ranger uniform, had become NPS director by 1932. As the dream of a Colonial National Park in Yorktown became a reality, Albright felt the NPS had finally begun its foray into historic site preservation "on a grand scale of some magnitude." As Albright turned his attention to new sites, Charles Peterson took on a larger role as the park's architectural historian. He would be the one chosen to design the Colonial Parkway and see it through to completion. (National Park Service, Colonial National Historical Park.)

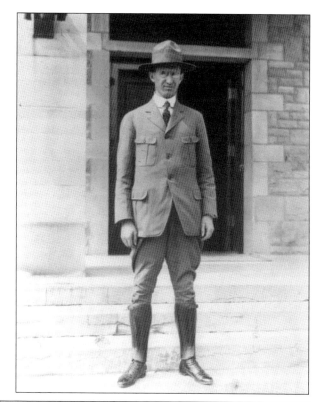

The restoration of Colonial Williamsburg began in 1926. Pictured here around 1928 are, from left to right, Rev. Dr. William Archer Rutherefoord Goodwin, Robert Trimble, John D. Rockefeller Jr., and Arthur Shurcliff. Shurcliff was a landscape architect working for the Williamsburg Holding Company. While their attention was primarily on the Colonial town, they were very interested in the development of the Colonial National Monument and parkway. They provided advice and (in some cases) financial support for both. Rockefeller purchased the Moore House, which would eventually be sold to and renovated by the NPS for the Yorktown Battlefield. He was kept apprised of Colonial Williamsburg's construction as well as the decisions being made on the parkway route. (CWF.)

Charles Peterson came to the Colonial National Monument as a young landscape architect. He had been assigned to the West Coast in San Francisco but was soon transferred to help complete the Skyline Drive. After a stop at the George Washington Birthplace National Monument, he started work in Yorktown. Peterson played a key role in the parkway's development and construction. Influenced in Colonial restoration, he designed the parkway's brick-laden culverts and overpasses to allow the motorist a consistent aesthetic experience while traveling from point to point along the road. Peterson wanted to cover the parkway's water bridges with brick as well, but this proved too expensive. In 1936, after his work in Yorktown and Williamsburg, Peterson founded the Historic American Buildings Survey (HABS), one of the premier historic document and drawing collections in the world. (Special Collections, University of Maryland Libraries.)

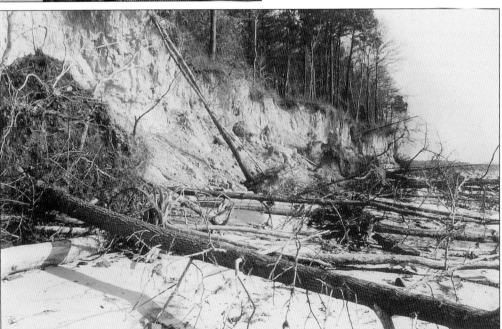

Some of the challenges that the contractors and the Civilian Conservation Corps (CCC) had to address during construction involved riverbank erosion. The erosion seen here dated back to the Civil War. Workers would remove the fallen trees and brush littering the shore and strengthen the cliffs where necessary. (National Park Service, Colonial National Historical Park.)

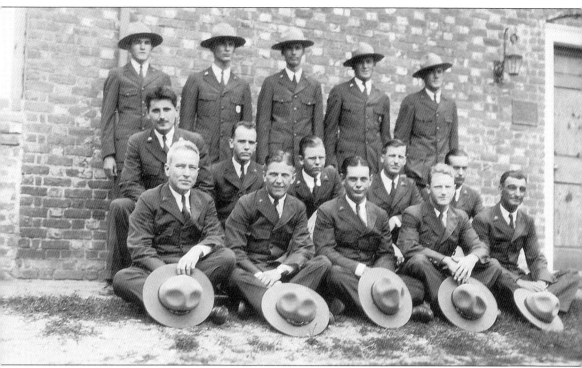

On Saturday, August 6, 1932, the Colonial National Monument staff gathered at the Customs House in Yorktown to have their picture taken. From left to right, they were (first row) W. M. Robinson Jr., H. W. Sorrill, E. H. Dunston, C. W. Cockrell, and A. L. Ayres; (second row) B. Floyd Flickinger, Elbert Cox, J. G. Fletcher, M. C. Voorhis, and H. R. Smith; (third row) W. W. Hodges, R. P. Holland, W. G. Banks, R. T. Hoakins, and M. E. Gardner. Three of the rangers pictured here would hold the superintendent's position during their careers: William M. Robinson Jr., the park superintendant at the time of the photograph, served from October 1931 until August 1933. He was followed first by B. Floyd Flickinger, who served as acting superintendent from August to December 1933, when he became the superintendent for the Colonial National Monument. Elbert Cox became superintendent after Flickinger in May 1939, and he served until November 1942. (National Park Service, Colonial National Historical Park.)

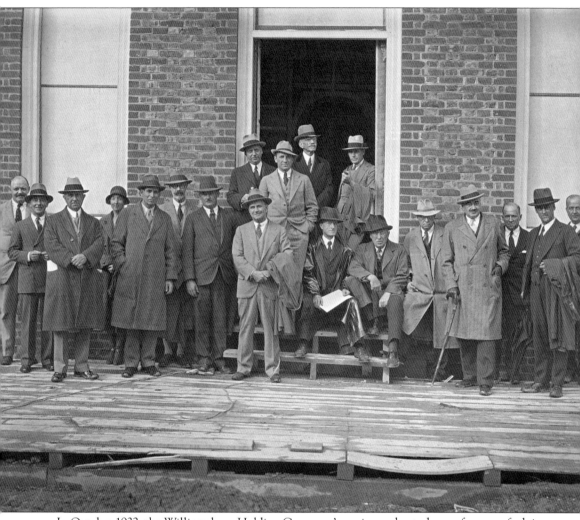

In October 1932, the Williamsburg Holding Company's engineers hosted a conference of advisory architects who were encouraged to provide input on the parkway and park. The attendees shown here from left to right are (first row) H. R. Shurtliff, Robert Trimble, Philip Stern, Susan Nash, Lawrence Kocher, Thomas Shaw, Edmund Campbell, Marcellus Wright Jr., Arthur A. Shurcliffe, Robert P. Ballows, Thomas Tallmadge, Fisk Kimball, Conrad Anner, William G. Perry, and A. Gary Lambert; (second row) Duncan Lee, Walter Macombet, D. Everett Wold, and A. H. Hepburn (CWF.)

Many of the architects who worked on the Colonial Parkway were influenced by the work of Frederick Law Olmsted and Calvert Vaux, designers of Manhattan's Central Park and Brooklyn's Prospect Park. (Horace Albright himself had worked with Olmsted on several NPS sites out west.) The overpasses so prominent in Charles Peterson's designs for the Colonial Parkway resemble those favored by Olmsted and Vaux. (LOC.)

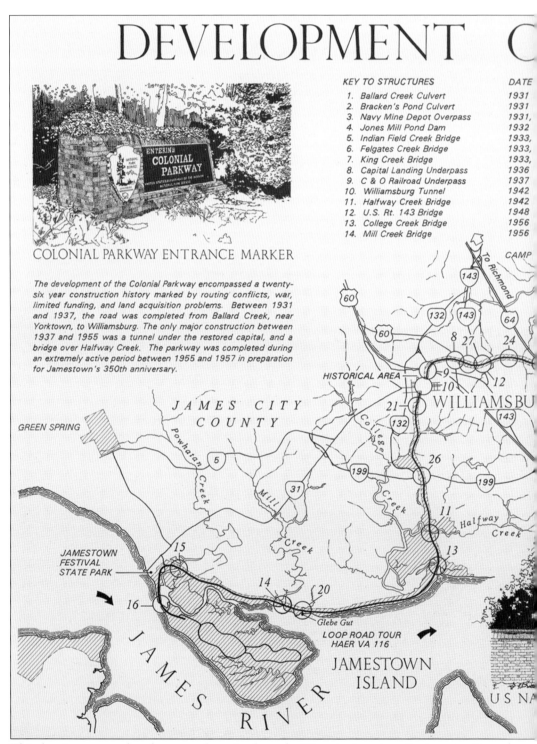

COLONIAL PARKWAY ENTRANCE MARKER

KEY TO STRUCTURES

		DATE
1.	Ballard Creek Culvert	1931
2.	Bracken's Pond Culvert	1931
3.	Navy Mine Depot Overpass	1931,
4.	Jones Mill Pond Dam	1932
5.	Indian Field Creek Bridge	1933,
6.	Felgates Creek Bridge	1933,
7.	King Creek Bridge	1933,
8.	Capital Landing Underpass	1936
9.	C & O Railroad Underpass	1937
10.	Williamsburg Tunnel	1942
11.	Halfway Creek Bridge	1942
12.	U.S. Rt. 143 Bridge	1948
13.	College Creek Bridge	1956
14.	Mill Creek Bridge	1956

The development of the Colonial Parkway encompassed a twenty-six year construction history marked by routing conflicts, war, limited funding, and land acquisition problems. Between 1931 and 1937, the road was completed from Ballard Creek, near Yorktown, to Williamsburg. The only major construction between 1937 and 1955 was a tunnel under the restored capital, and a bridge over Halfway Creek. The parkway was completed during an extremely active period between 1955 and 1957 in preparation for Jamestown's 350th anniversary.

This drawing was produced as part of a series from the Historic American Engineering Record (HAER). The HAER drawing shown here was created in 1995 by the NPS and the American Society of Civil Engineers. These documents' purpose was to detail historic sites and structures.

THE PARKWAY

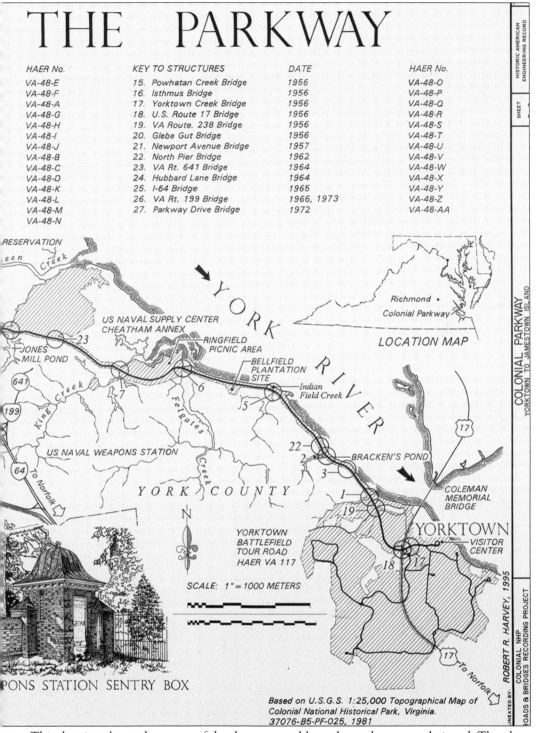

LOCATION MAP

SCALE: 1" = 1000 METERS

PONS STATION SENTRY BOX

Based on U.S.G.S. 1:25,000 Topographical Map of
Colonial National Historical Park, Virginia.
37076-B5-PF-025, 1981

COLONIAL PARKWAY
YORKTOWN TO JAMESTOWN ISLAND

HISTORIC AMERICAN
ENGINEERING RECORD

SHEET

DELINEATED BY: ROBERT R. HARVEY, 1995
COLONIAL NHP
ROADS & BRIDGES RECORDING PROJECT

This drawing shows the stages of development and how the parkway was designed. The plans also described the various underpasses, overpasses, and bridges that were built. (National Park Service, Colonial National Historical Park.)

Harold L. Ickes served as U.S. Secretary of the Interior under Franklin D. Roosevelt for 13 years. He traveled with NPS director Albright to some of the parks and historic sites within driving distance of Washington, D.C. He took up the cause of the National Park Service. He also took charge of administering the Public Works Administration and the New Deal construction plan and used the programs to build bridges, tunnels, and dams. (LOC.)

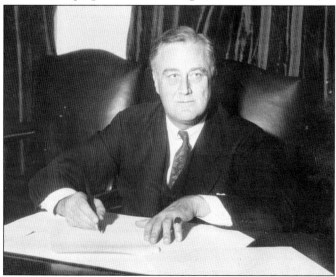

Pres. Franklin D. Roosevelt attended the sesquicentennial celebration for the victory at Yorktown in 1931, as governor of New York. Albright had met Roosevelt on several occasions and always took the opportunity to keep him updated and enlist his support. On August 22, 1933, as president, Roosevelt issued a proclamation to enlarge the boundaries and increase the area of the Colonial National Monument. (LOC.)

Three

CONSTRUCTION OF THE PARKWAY

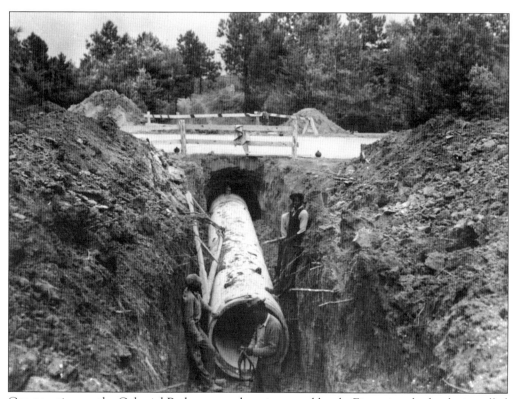

Construction on the Colonial Parkway was done in several levels. First, pipes had to be installed to make sure there was adequate drainage under the road. On October 12, 1942, these pipes were being run under the parkway for the Chickahominy water-line crossing. (National Park Service, Colonial National Historical Park.)

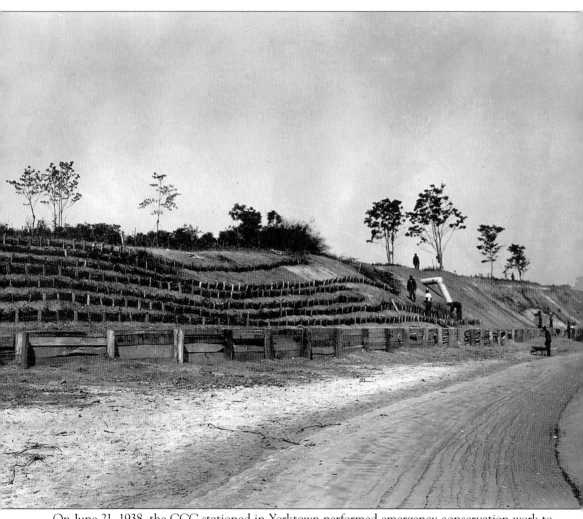

On June 21, 1938, the CCC stationed in Yorktown performed emergency conservation work to preserve the York River cliffs along the parkway from erosion. This included building the bulkhead and laying rows of wattles. The workers also had to arrange sloping, which was necessary for drainage. (National Park Service, Colonial National Historical Park.)

From 1955 to 1957, construction on the area known as Archer's Hope required clearing and grading before the road could be laid. In this picture, the road is being positioned to parallel the James River. (National Park Service, Colonial National Historical Park.)

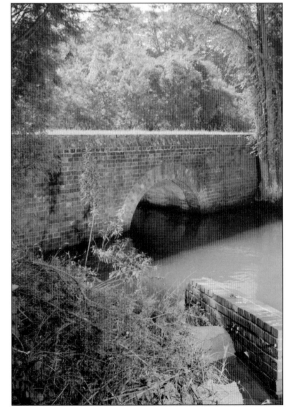

The Ballard Creek Culvert was built to allow Ballard Creek to empty into the York River. It was designed as an 8-foot concrete arch covered with the handmade "James Towne Collony" bricks that were used for the overpasses and bridges throughout the Yorktown-to-Williamsburg section of the parkway. (National Park Service, Colonial National Historical Park.)

Weather played a part in many delays and rerouting that occurred as the parkway was under construction. The rains created so much mud and erosion that a large percentage of the work performed by the men from the Yorktown CCC camp, in the 1930s, was simply emergency conservation. The snow seen covering the road here in the 1950s was beautiful to look at, but it caused route closures and landscape and road damage. (National Park Service, Colonial National Historical Park.)

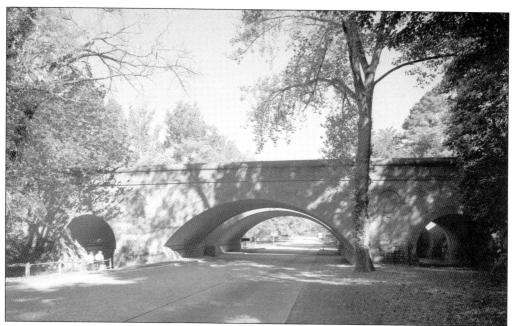

The Chesapeake and Ohio (C&O) Railroad underpass, shown here, was the very first of nine overpasses or underpasses built along the parkway in the 1930s. It used the handmade bricks employed at all the sites along the Yorktown-to-Williamsburg path. The underpass consisted of two separate bridges—one for the rails and the other for vehicles on Lafayette Street. Charles Peterson and Arthur Shurcliff designed the 50-foot span. (National Park Service, Colonial National Historical Park.)

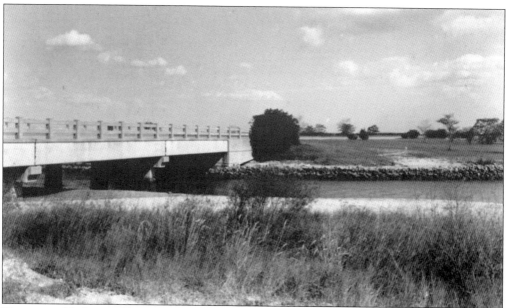

The original Indian Field Creek Bridge was constructed of concrete, but in 1980, it was completely rebuilt with a new bridge deck, walls, and railing. The new railing was shortened, as the original railing did not fit the style used on the other bridges. (National Park Service, Colonial National Historical Park.)

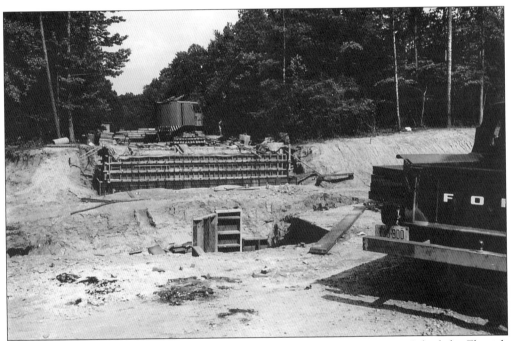

Queens Lake overpass was built in the same style as the earliest overpasses. It had the Flemish bond style brick and a concrete structure. The arched design was beveled, and half-round bricks were used for construction. (National Park Service, Colonial National Historical Park.)

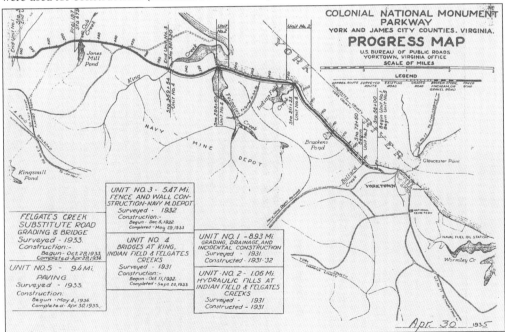

By April 1935, the parkway stretched from Yorktown to Williamsburg. The work had been done using contractors for construction and the CCC for emergency conservation work and roadside plantings. The U.S. Bureau of Public Roads worked with the NPS to make sure the work was completed in a timely manner. (National Park Service, Colonial National Historical Park.)

34

The Colonial Parkway not only served as a byway to take tourists from one historical site to another, but it allowed visitors to stop and observe their surroundings. With this in mind, the designers included pull-offs along the parkway. Originally the parkway featured 17 of these mini-rest areas. Interpretive markers were added in the 1950s. Some of the pull-offs also provided parking areas for recreational users of the park. (National Park Service, Colonial National Historical Park.)

CLEARING & GRUBBING

After the road alignment was approved, Bureau of Public Roads survey teams set stakes along the location of the road's slopes, and all ground cover was cleared to a distance of 5' beyond the stakes. Directed by the landscape architects, the supervisory engineers were responsible for marking certain trees for preservation. All locust and cedar trees with a minimum diameter of 6" were cut to board length and saved. All other material cleared was burned at night in specified areas.

SLOPE DEVELOPMENT

Landscape architects gave special attention to the development of vegetated slopes along the Colonial Parkway to set the road into the landscape. Tree stumps along slope areas were left below the surface to help stabilize the embankments. A varying grade between 2:1 and 5:1 was used, but the engineer was responsible for on-site supervision to adjust the slopes to local conditions. Following detailed plans from the landscape division, the proper grade was attained, and crews seeded the slopes to stabilize the earth before beautification.

PAVING

A two course subgrade between 9" and 12" thick underlies most of the pavement along the parkway. Form work and reinforcement mesh were constructed for the concrete sections, which were 10' wide and between 40' and 60' long. Concrete was mixed with a local aggregate (primarily marl) and poured first in the center 10' wide crowned section. Special treatments, including hosing, brooming, and acid washes were used to expose the aggregate and create the feel of a "country road." (see drawing No. 6 for detail).

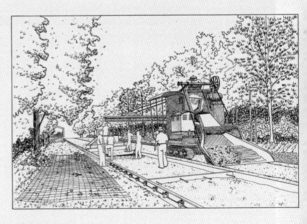

As part of the HAER series, this drawing shows the six stages involved in building the Colonial Parkway: clearing and grubbing the land to prepare it for grading, slope development to assure

EXCAVATION & GRADING

With the right-of-way cleared and grubbed, the bedding for drainage structures was excavated, and the roadway, overlooks, and parking areas were graded in accordance with the specifications on the plans. Topsoil was removed from the area to be paved, and stored for replacement upon slopes for planting. Drainage structures were constructed and backfilled, and a suitable subgrade was attained. Excavated earth was used to create embankments, and to top areas of hydraulic fill.

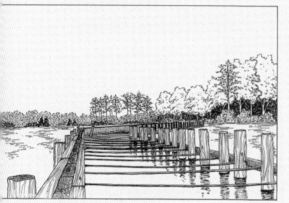

HYDRAULIC FILL

The decision to align the parkway along the York and James rivers necessitated the extensive use of hydraulic fill to create a suitable road grade at a minimum elevation of 11' above sea level. Timber bulkheads were constructed to stabilize the fill material dredged from specified areas along the river bed. Utilizing the bleeding process of hydraulic fill, a discharge pipe was placed at the centerline of the embankment through which dredged material was allowed to run out and settle naturally.

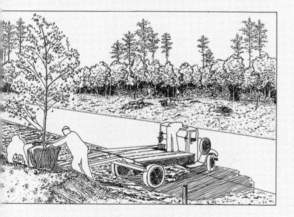

PLANTING

The primary planting season along the Colonial Parkway usually extended from the fall to early winter. New trees, such as pines, dogwoods, and cedars, were planted along the road, and many existing trees were moved to create balance and variety to the roadscape. While funds for purchasing plant material were allocated to the CCC camps through Emergency Conservation Works programs, deals were often made with local landowners to donate trees in exchange for the grading and surfacing of roads on their property.

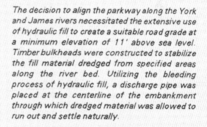

HISTORIC AMERICAN ENGINEERING RECORD
SHEET
COLONIAL PARKWAY
YORKTOWN TO JAMESTOWN ISLAND
DELINEATED BY: Kevin Doniere, 1995
COLONIAL NHP
ROADS & BRIDGES RECORDING PROJECT

drainage and reduced erosion, excavation and grading to smooth out the path, laying the road, and planting. (National Park Service, Colonial National Historical Park.)

Created by the U.S. Congress in March 1933, the CCC was established as a jobs program for unmarried men between ages 18 and 25. CCC camps were established across the country, including ones in Williamsburg and Yorktown. The Yorktown camp, No. 323, was established June 19, 1933. Capt. Moe D. Baroff of Richmond was put in charge. The camp included four companies. The NPS used these men during construction of the parkway to assist in planting and erosion conservation. They also worked on excavation of the battlefields, construction of furniture, and fabrication of cannon carriages for exhibits. The camp included sleeping quarters, an infirmary, mess hall, activity hall, and staff buildings. The men made about $30 per month plus meals and a place to sleep. Men were required to send most of their money home to support their families. (National Park Service, Colonial National Historical Park.)

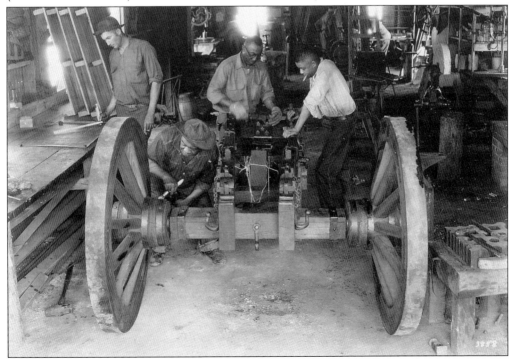

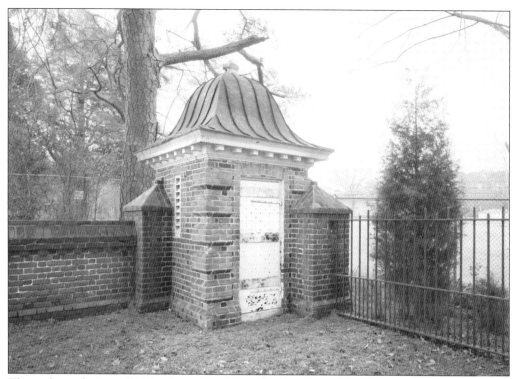

The parkway design called for the road to follow the shoreline of the York River on navy property. Along with the parkway, improvements on the U.S. Navy's land were supposed to include new barracks, fencing, entry gates, and additional roads adjoining the parkway. Most of these additions were not completed. (National Park Service, Colonial National Historical Park.)

The leaders behind the restoration of Colonial Williamsburg wanted to build a visitor center that was both convenient to the historic district and able to handle large numbers of tourists. They looked at a number of possible locations for this project, including this site off the parkway and near the exits to Williamsburg. (National Park Service, Colonial National Historical Park.)

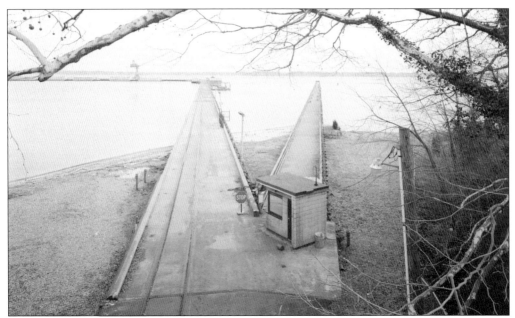

The Navy Mine Depot overpass was built to give access to a road that sloped down to the navy pier on the York River. It featured 3-foot brick parapet walls and apex piers and was one of the parkway's first overpasses. (National Park Service, Colonial National Historical Park.)

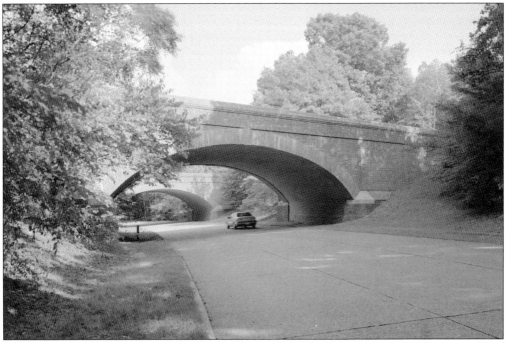

In the early 1960s, Virginia built Interstate 64 toward the Tidewater area. By 1965, the road had reached Williamsburg. At this point, two bridges were built to cross over the parkway. Driving beneath the scenic brick overpasses on the parkway, most travelers never imagine that a heavily trafficked interstate looms above this idyllic setting. (National Park Service, Colonial National Historical Park.)

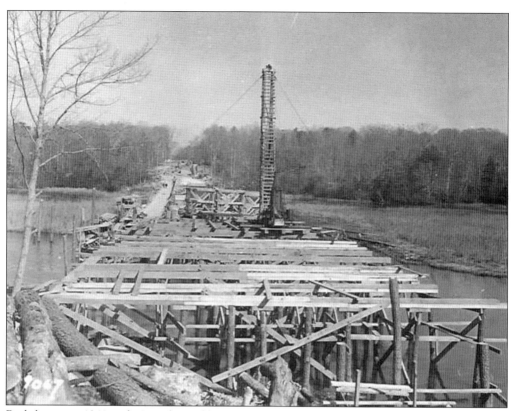

Built between 1941 and 1943, the Halfway Creek Bridge was one of the last major construction projects begun before building stopped during World War II. The parkway was eventually completed in the mid-1950s in preparation for the 350th anniversary of the Jamestown landing. (National Park Service, Colonial National Historical Park.)

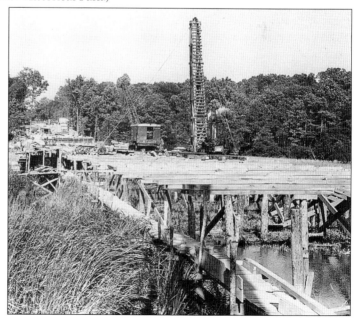

Built by Frank P. Westcott Company of North America, the 600-foot-long Halfway Creek Bridge was the lengthiest span built along the parkway. It had 28-inch-high railings and a 3-foot walkway on the side nearest College Creek. When this photograph was taken in 1942, the bridge was about 85 percent complete. (National Park Service, Colonial National Historical Park.)

The parkway was covered with river gravel—small rocks worn smooth by water. The concrete aggregate had the rocks embedded on it to make a more appealing, rustic-looking road. Some believe that the parkway may be the longest public highway in the world surfaced with river gravel. Kings Creek, below, is one of the bridges that reflects this road structure. It was constructed as a single-arch concrete bridge. (National Park Service, Colonial National Historical Park.)

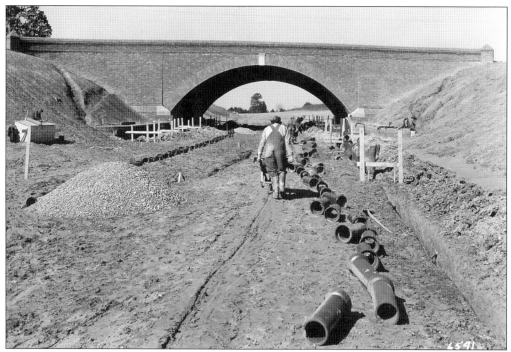

This March 12, 1938, photograph shows workers preparing to install the drains on the Capital Landing Road underpass. When finished, the concrete bridge over the underpass was 156 feet long and covered with handmade bricks. Seen here at the apex of the arch is its decorative 6-foot granite keystone. (National Park Service, Colonial National Historical Park.)

Workers began construction of the C&O Railroad overpass in April 1936 on the east side of England Street. When completed, it gracefully carried three railroad tracks and Lafayette Street across the parkway. (National Park Service, Colonial National Historical Park.)

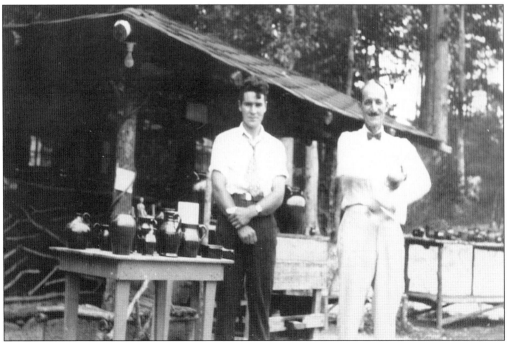

All of the bricks used to construct the overpasses and bridges on the Colonial Parkway from Yorktown to Williamsburg were made by Paul Matthew Griesenauer and his son, Paul Raymond Griesenauer. The elder Griesenauer and his wife, Helen Irene Carter Griesenauer, came to the Williamsburg area from Detroit around 1919. He became the manager of the Pine Dell Plantation, experimented with plantings, wrote for horticulture magazines, and took up ceramics. He studied the way colonists had made pottery and bricks. This interest led to his forming the Jamestowne Collony Pottery Company, and he began making his own pottery and bricks. (Betty Griesenauer Price.)

The details of the brickwork on the overpasses on the parkway are a testament to the dedication of Paul M. Griesenauer. He was commissioned by the government to produce the bricks that would go on the overpasses, underpasses, and bridges. When the bricks were completed, he stamped them with the name of his company, Jamestowne Collony Pottery. (National Park Service, Colonial National Historical Park.)

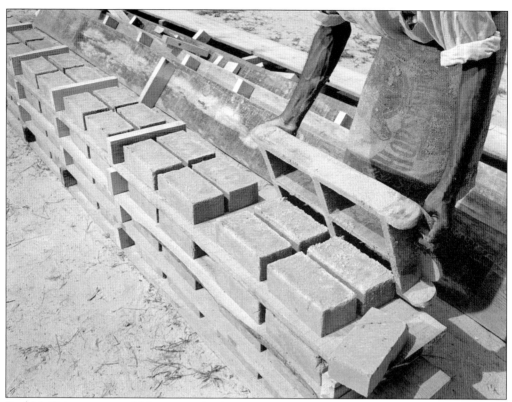

Paul M. Griesenauer and his son received the contract to make the Colonial Parkway's bricks in 1933. Knowing that he needed to make his bricks with the same sort of equipment used during the Colonial period, Griesenauer met with an elderly brick maker who had created the bricks for the Massachusetts Building in the 1907 Jamestown Exposition. The brick maker said he had used two brick wheels made in 1868, located at a mill at Oyster Point. Griesenauer and the brick maker went there and were thankful to find one of them without any rust on the steel. This single wheel was used to make every brick along the parkway. (CWF.)

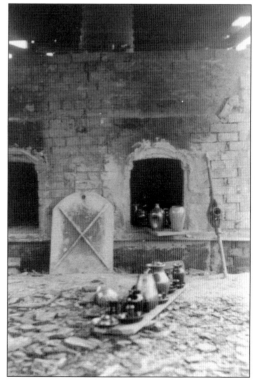

The Griesenauers used this kiln to fire the pottery and bricks needed for the construction of both the parkway and St. Bede's Catholic Church in Williamsburg. The kiln was so large that the brick makers could walk into it to deposit the pottery and bricks before firing and return afterwards to remove them. The kiln was located on the elder Paul's property about 1.5 miles from his house. (Betty Griesenauer Price.)

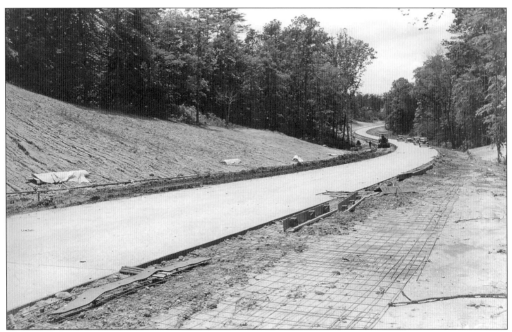

The parkway was built as a unique three-lane road so that motorists could focus more attention on the surrounding landscape rather than oncoming traffic. Today passing zones are strictly limited for traffic safety reasons. The Bureau of Public Roads's engineers were responsible for the design and supervision of the parkway, but the NPS landscape architects determined how the parkway would look, how it would be graded, and what would be planted along the way. Before the CCC came in 1933, the clearing and planting work was performed by prisoners interned at the U.S. Army's Fort Eustis in Newport News. (National Park Service, Colonial National Historical Park.)

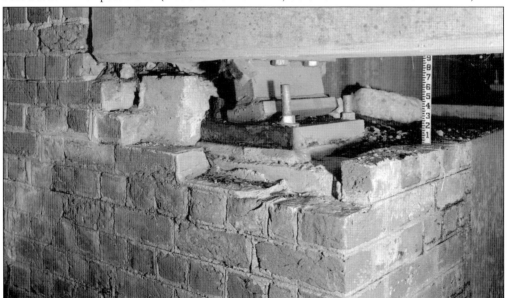

The overpasses were at times supported by rocket mounts. These fortified and supported the overpasses' pillars while allowing for movement and adjustment. These mounts were considered groundbreaking engineering feats in their time. (LOC.)

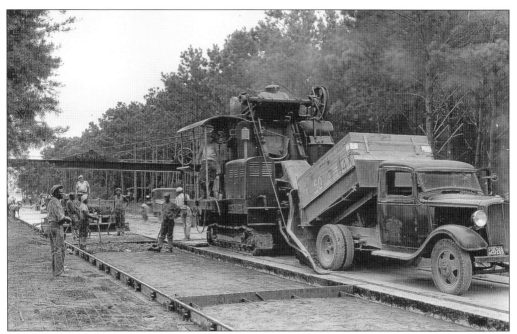

The Rex machine shown here could create up to 350 yards of concrete in a day. Construction workers used it to lay the parkway's concrete. In this photograph taken on August 10, 1934, the skip is being loaded with dry mixture from the truck. (National Park Service, Colonial National Historical Park.)

The CCC stationed in Yorktown was charged with watering the shrubs, trees, and other foliage planted along the parkway. (National Park Service, Colonial National Historical Park.)

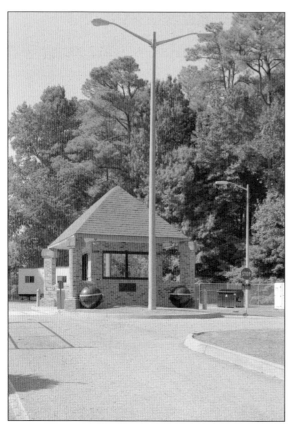

Built in the Colonial style to preserve the parkway's aesthetics, on January 6, 1979, the new Capello Gates guardhouse was opened as an entryway into the Yorktown Naval Weapons Station. (National Park Service, Colonial National Historical Park.)

The north pier overpass shows the view from the access road built beneath it for the U.S. Navy. The detailed brick pattern was modeled after the mine depot's other overpass and features a 3-foot wall. (National Park Service, Colonial National Historical Park.)

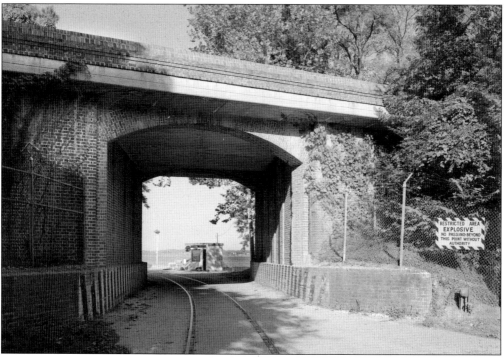

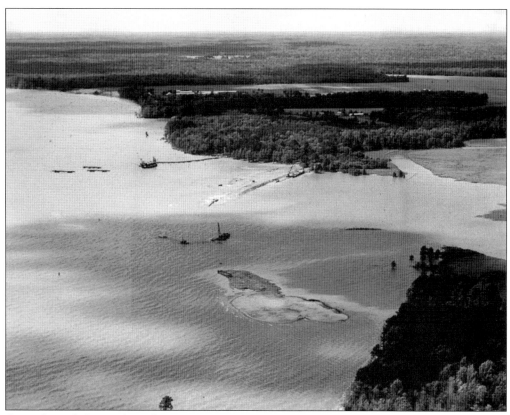

As evidenced above, the isthmus connecting Jamestown Island to the mainland at Glasshouse Point was washed out in the 1700s. When the colonists first came to Jamestown, the isthmus was still intact. They would use it for over a century. With erosion caused by the movement of the James River over the years, in time, the isthmus was gone. When the NPS continued the parkway to Jamestown Island in the mid-1950s, they rebuilt the isthmus for motor traffic as seen below. (National Park Service, Colonial National Historical Park.)

Cheatham Annex, named after Rear Adm. Joseph J. Cheatham, was created during World War II as part of the naval base in Norfolk. The land on which Cheatham Annex was built had formerly been the site of several small towns. One of the largest of these was the town of Penniman. It was taken over by the U.S. Navy Mine Depot in 1943 to provide services to the Atlantic Fleet based in the Tidewater area. Construction of the parkway overpass was designed to allow access to Penniman Road but still give naval personnel easy access to the annex. (National Park Service, Colonial National Historical Park.)

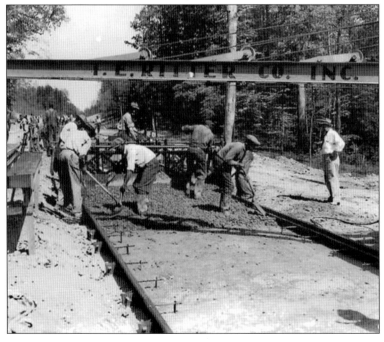

T. E. Ritter Company, Inc., paved sections of the parkway's Yorktown to Williamsburg leg. In this photograph, workers are "spreading," filling forms with concrete and then leveling the concrete. They did this in three sections, creating the "think gaps" that allow for the expansion and contraction of the parkway. (National Park Service, Colonial National Historical Park.)

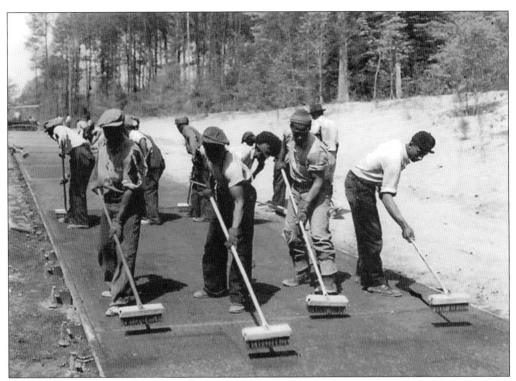

In 1938, construction crews are "brooming" the road to expose the aggregate and give the parkway a finished surface. (National Park Service, Colonial National Historical Park.)

Motorists would first spot the bridge at College Creek when they emerged from the woods and began the drive along the James River. The 87-foot-long bridge was built between 1955 and 1956. College Creek, formerly known as Archer's Hope Creek, has appeared in the pages of history several times; over the years, Spanish explorers, British colonists, and the Confederate army all passed by here. (LOC.)

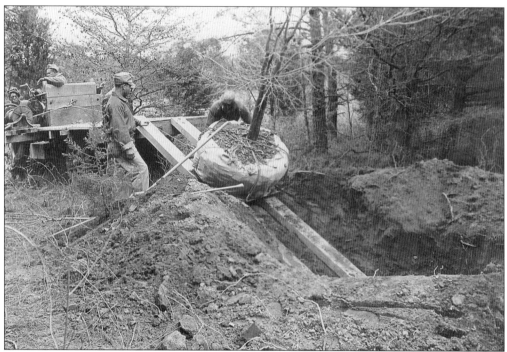

Planting on the parkway was an ongoing event and critical to the realization of one of the scenic byway's original purposes, showcasing the Tidewater region's indigenous natural beauty. By April 1936, Colonial Parkway superintendent B. Floyd Flickinger announced that 14,592 trees had been planted—a mix of oak, maple, holly, gum, sycamore, and "transplants." Some 16,791 dogwoods and 517 red bud had also been planted. From 1933 to 1936, parkway landscaping crews (mostly CCC men) had installed or replanted around 60 trees a day, all of which varied in size from 1 to 5 tons. Sometimes local farmers also donated plants and assisted in their installation in trade for having paving done on their property. (National Park Service, Colonial National Historical Park.)

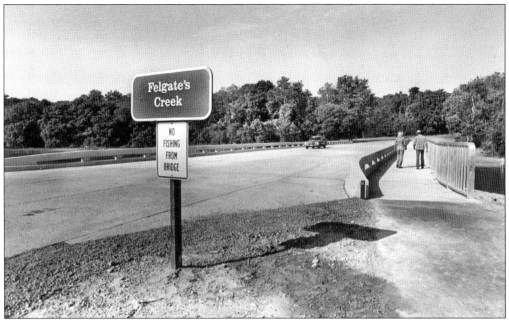

Over the years, weather and traffic have made repairs to the parkway necessary. Felgate's Creek Bridge, seen here, went through a major reconstruction in early 1980, during which time a bike path was added to the right of the bridge. Parts of the parkway had been closed during this project but it was opened in time for the celebration of the 199th anniversary of the end of the American Revolution. (The *Daily Press*.)

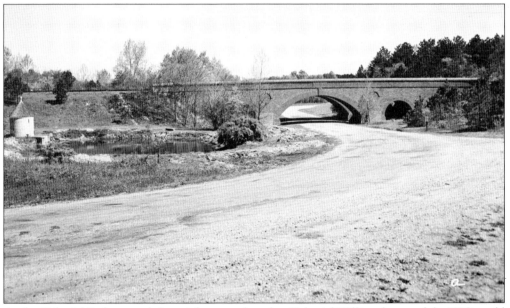

As the Colonial Parkway took form, it became clear that Colonial Williamsburg and the NPS would need to work closely with one another to make the parkway and the historic area complement one another for the good of the entire region. When the time came to build a visitor center for Colonial Williamsburg, it was logical that the planners would look at a site near the parkway. This photograph shows one of the sites considered for the new building. (CWF.)

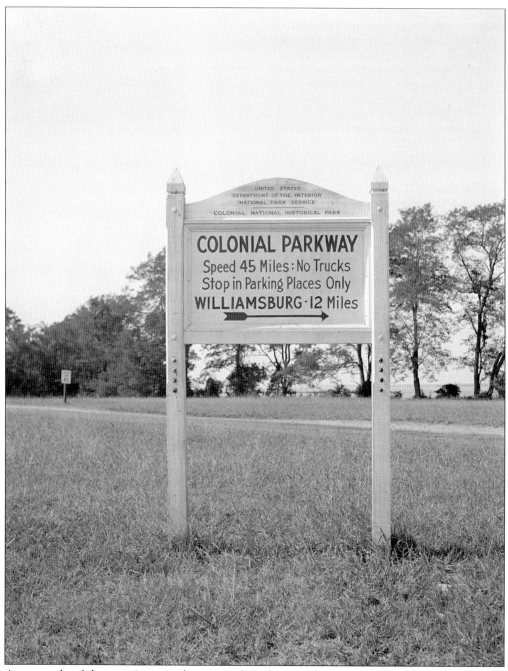

An example of the route's original signage, this white marker stood at the Yorktown entrance to the parkway. Though this picture was taken on September 16, 1948, the rules seen here are still in effect today. Eventually signs like this were replaced with more permanent ones. (CWF.)

Four

THE TUNNEL

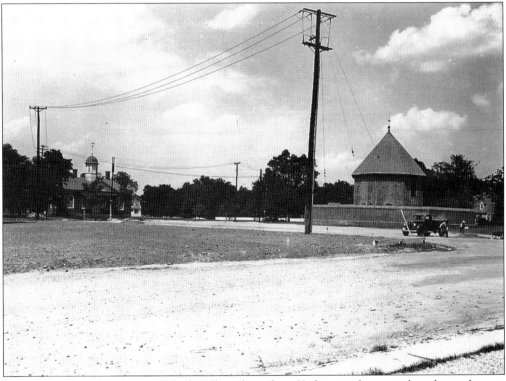

After the Colonial Parkway reached Williamsburg from Yorktown, the next obstacle was how to get through Williamsburg. Two overland paths were discussed, and each of them had ardent and influential supporters. However, once a tunnel was chosen as the way to get the Colonial Parkway through Williamsburg, everyone united around the idea. This view shows Francis Street (foreground) looking toward East Nicholson Street, with the powder magazine to the right and the courthouse in the background. At the time of this photograph, the renovations have clearly not been completed; telephone poles and lines are still visible. The tunnel would pass between the powder magazine and the courthouse. (National Park Service, Colonial National Historical Park.)

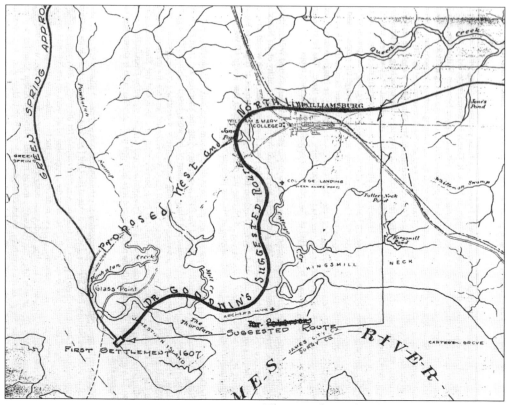

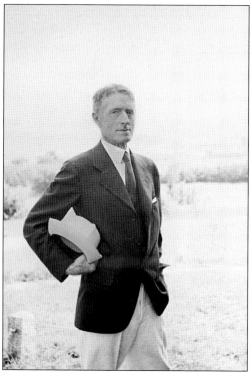

The map shows the aboveground routes proposed for the path to get the Colonial Parkway through Williamsburg. A path suggested by Charles Peterson cut through the east side of the town, but passed too close to Bassett Hall and other historical buildings. The second option would have gone on the other side of town, traveling by Green Springs Plantation. As the debate went on, Rev. Dr. W. A. R. Goodwin made the case for installing a tunnel, which was eventually adopted. (National Park Service, Colonial National Historical Park.)

Pictured here is Boston-born landscape architect Arthur Shurcliff, who designed Colonial Williamsburg's reconstructed gardens. He, too, proposed an overland route through Williamsburg, but his idea lost out to Goodwin's tunnel proposal. (CWF.)

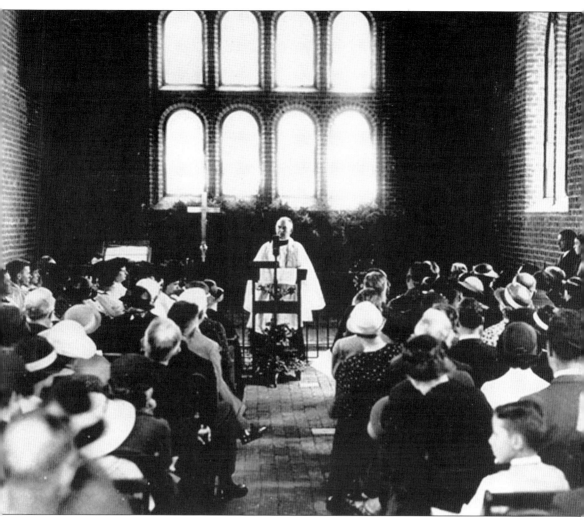

Rev. Dr. W. A. R. Goodwin, rector of Williamsburg's historic Bruton Parish Church, had long supported the building of what he called "Pathfinders Road," a byway to carry tourists from Jamestown through Williamsburg and on to Yorktown. Goodwin's involvement continued throughout the parkway's development and construction. Goodwin was consulted on the path of the road and was the man behind the idea to build a tunnel. Reverend Goodwin is shown here at a service held at the Jamestown Memorial Church. (LOC.)

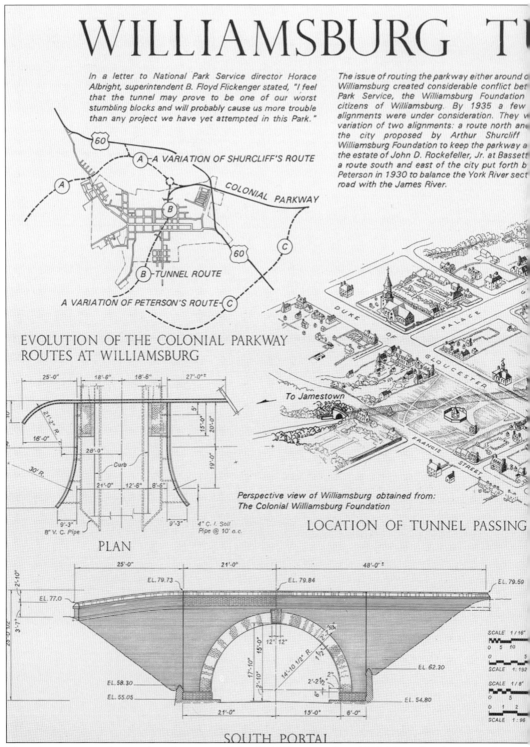

In a letter to National Park Service director Horace Albright, superintendent B. Floyd Flickenger stated, "I feel that the tunnel may prove to be one of our worst stumbling blocks and will probably cause us more trouble than any project we have yet attempted in this Park."

The issue of routing the parkway either around o[...] Williamsburg created considerable conflict bet[...] Park Service, the Williamsburg Foundation [...] citizens of Williamsburg. By 1935 a few [...] alignments were under consideration. They w[...] variation of two alignments: a route north an[...] the city proposed by Arthur Shurcliff [...] Williamsburg Foundation to keep the parkway a[...] the estate of John D. Rockefeller, Jr. at Bassett[...] a route south and east of the city put forth b[...] Peterson in 1930 to balance the York River sect[...] road with the James River.

60

A - A VARIATION OF SHURCLIFF'S ROUTE

COLONIAL PARKWAY

A

B

60

C

B - TUNNEL ROUTE

A VARIATION OF PETERSON'S ROUTE - C

EVOLUTION OF THE COLONIAL PARKWAY ROUTES AT WILLIAMSBURG

To Jamestown

Perspective view of Williamsburg obtained from: The Colonial Williamsburg Foundation

DUKE OF GLOUCESTER

PALACE

FRANCIS STREET

LOCATION OF TUNNEL PASSING

PLAN

SOUTH PORTAL

SCALE 1/16"

SCALE 1:192

SCALE 1/8"

SCALE 1:96

This drawing was also produced as part of the HAER, started in 1969. This sketch shows the details of how the tunnel was built, its path across town, and elements of its entrances. (National

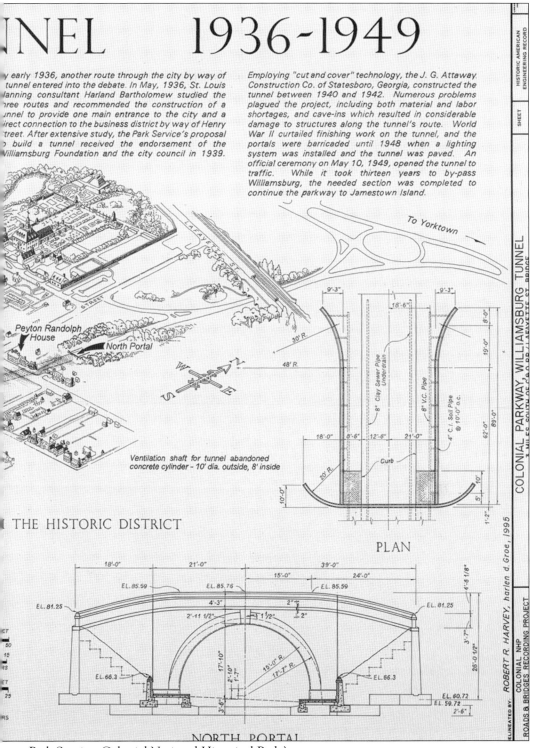

y early 1936, another route through the city by way of tunnel entered into the debate. In May, 1936, St. Louis lanning consultant Harland Bartholomew studied the hree routes and recommended the construction of a unnel to provide one main entrance to the city and a irect connection to the business district by way of Henry treet. After extensive study, the Park Service's proposal build a tunnel received the endorsement of the Villiamsburg Foundation and the city council in 1939.

Employing "cut and cover" technology, the J. G. Attaway. Construction Co. of Statesboro, Georgia, constructed the tunnel between 1940 and 1942. Numerous problems plagued the project, including both material and labor shortages, and cave-ins which resulted in considerable damage to structures along the tunnel's route. World War II curtailed finishing work on the tunnel, and the portals were barricaded until 1948 when a lighting system was installed and the tunnel was paved. An official ceremony on May 10, 1949, opened the tunnel to traffic. While it took thirteen years to by-pass Williamsburg, the needed section was completed to continue the parkway to Jamestown Island.

To Yorktown

Peyton Randolph House

North Portal

Ventilation shaft for tunnel abandoned concrete cylinder - 10' dia. outside, 8' inside

THE HISTORIC DISTRICT

PLAN

NORTH PORTAL

Park Service, Colonial National Historical Park.)

COLONIAL PARKWAY, WILLIAMSBURG TUNNEL

ROBERT R. HARVEY, harlen d. Groe, 1995

ELINEATED BY: COLONIAL NHP
ROADS & BRIDGES RECORDING PROJECT

HISTORIC AMERICAN ENGINEERING RECORD

SHEET

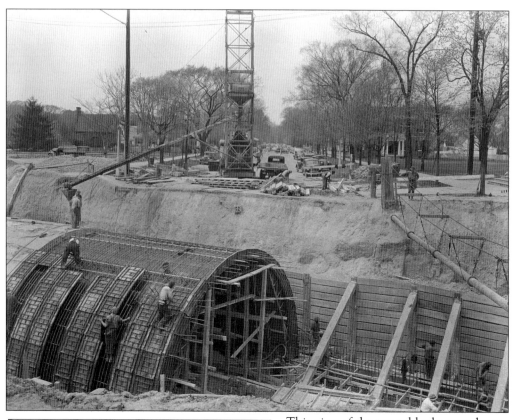

This view of the tunnel looks west down Duke of Gloucester Street toward William and Mary. The framing for the shape of the tunnel can be seen. The contractor was using a cut and cover construction for the 30-foot-wide tunnel. The result was a technological marvel that still functions today, providing enjoyment and convenience to the public. (CWF.)

John D. Rockefeller Jr. kept abreast of events of importance in the Historic Triangle, and the development of the park and parkway were no exception. He provided advice and funding at various points along the way and helped preservation efforts by purchasing the Moore House, the historic site where the British surrendered to the Americans. After the Colonial National Monument was created, Rockefeller sold the structure to the NPS; it became the first historic home restored by the fledgling park system. (CWF.)

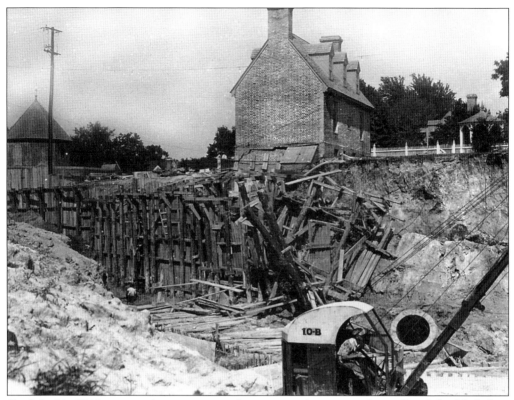

On July 31, 1940, a tunnel cave-in caused extensive damage to the walls of the Nicholas-Tyler Laundry. A well gazebo stands to the right of the building where the white fence ends. (National Park Service, Colonial National Historical Park.)

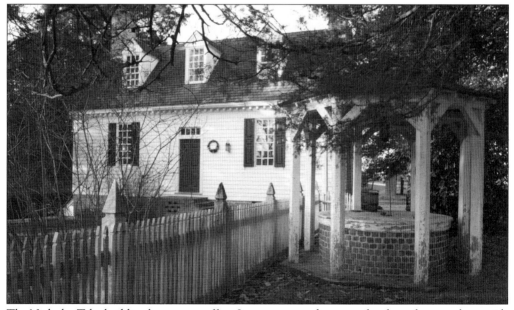

The Nicholas-Tyler building became an office. It was converted to a wooden frame house to keep with the area's Colonial theme. The gazebo still stands to the right of the house. (Katherine Clark.)

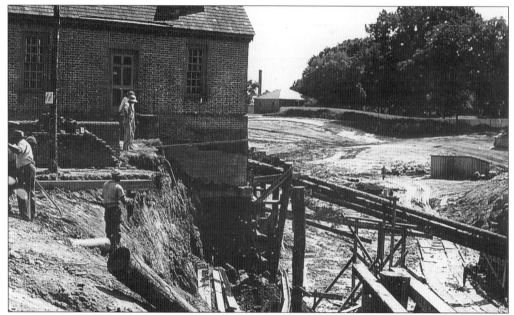

The tunnel suffered numerous cave-ins. Once the shell was set and formed and a lining was installed, workers would begin to put the dirt back down. The soil then needed to be allowed to settle before anything else could be done. On August 6, 1941, the *Daily Press* reported that Francis, England, and Duke of Gloucester Streets were still dusty and bumpy following the recent installation of sewer lines in conjunction with the tunnel construction. (National Park Service, Colonial National Historical Park.)

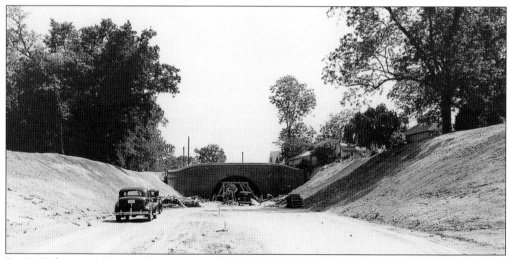

By 1947, the tunnel—seen here at its north entrance—had still not been paved. When it rained, water would seep into the tunnel, turning the floor to mud. On March 31, 1947, NPS regional director Thomas J. Allen wrote to the Colonial Williamsburg Foundation's A. E. Kendrew suggesting that they make the tunnel's paving a high priority and ask Congress for the funds required to complete the project. He asked Kendrew for Williamsburg city planner Bartholomew's advice on how to proceed with building the ramp to Francis Street, and he noted the need to pave the road near the ramp. Despite the obvious urgency in Allen's letter, Francis Street would remain unpaved for another two years. (National Park Service, Colonial National Historical Park.)

In early 1949, the tunnel was ready to be opened, but the ramp leading to a public road in Williamsburg was not completed until later in the year. This April 29, 1949, photograph taken from the tunnel's south portal shows the Francis Street ramp in its final stages of construction. (National Park Service, Colonial National Historical Park.)

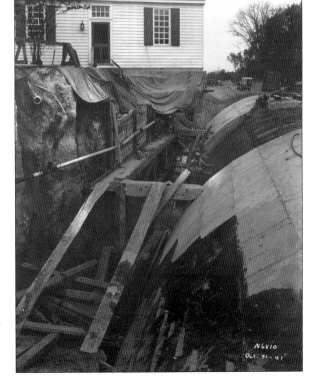

Details of the tunnel's framing are shown here on October 31, 1941. Note that the Nicholas-Tyler Laundry is almost completely repaired, and the formation of the tunnel's shape is progressing. (*Virginia Gazette*.)

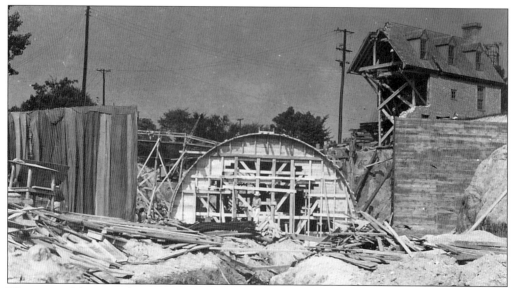

This view of the tunnel construction was taken from the south portal. It shows the destruction that the cave-in caused to the Nicholas-Tyler Laundry. By the time of this photograph, the tunnel's shape has taken form. The tunnel, which would eventually reach 1,183 feet in length, was supposed to be completed by the summer of 1941; however, it was not finished until 1942. (National Park Service, Colonial National Historical Park.)

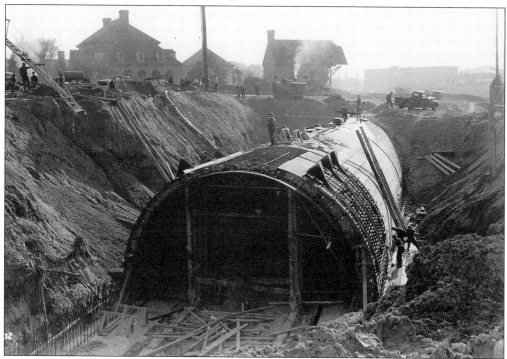

The tunnel walls were formed with frames and concrete. The CCC was tasked with helping to cover the tunnel with dirt once it had been formed and fitted together. They would put the dirt down and wait for it to settle before the roads could be put back down. (National Park Service, Colonial National Historical Park.)

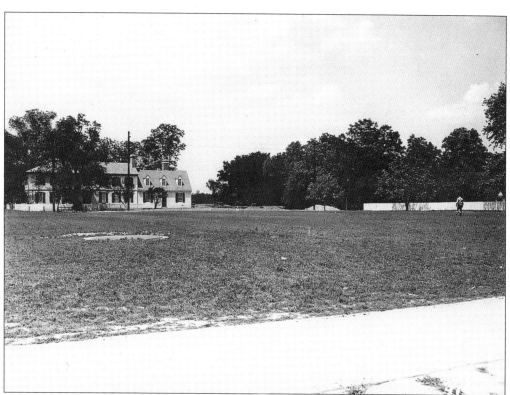

A critical part of creating the tunnel was making sure it had sufficient ventilation to allow for air and fumes to escape. A vent system was installed with a flat round metal cap with the shaft opening in the tunnel's roof. Above ground, the shaft rose about 2 inches above the surface of the soil, emerging to the right of the old courthouse, where it can still be seen today. (Above, NPS; right, Katherine Clark.)

Interpretive markers line the completed parkway, positioned at various pull-offs along the parkway so that drivers can park and read them. The markers, created by NPS superintendent Stanley Abbott and park landscape architect Robert Steenhagen in the 1950s, enhance the motorist's experience with information and mark the progression of events from Jamestown to Yorktown. These markers were recognized in the write up when the Colonial Parkway attained a place on the National Register of Historic Places. (Katherine Clark.)

Five

THE JAMESTOWN MARKERS

Each of the interpretive markers along the parkway includes a circular symbol with an area feature displayed on the marker. The symbol on the parkway's Jamestown-to-Williamsburg section shows one of the three ships that brought the first English settlers to the New World, anchored off Jamestown Island. Here in the spring of 1607, three ships brought colonists who settled on an island in the James River, building the first permanent English settlement in what would become Virginia. (Katherine Clark.)

Jamestown Island was developed in the 1930s to offer tourists a chance to view the village's ruins and interpretive museum displays as well as give them the feeling of what it was like to see the island as the colonists would have seen it when they arrived. In 1954, plans were developed to provide an interpretive wilderness road. Discussions included a loop that would display the activities colonists experienced. Gilmore D. Clarke of the Clarke and Rapuano firm was hired to make recommendations on how to develop this concept. His solution included a tractor-train tour of the island, similar in concept to the one at the New York Zoo. However, the NPS felt it would seem artificial and would not give the experience they wanted visitors to have. It was decided there would be a loop road 5 miles long that would feature paintings by Virginia artist Sidney King showing how the first settlers used the land. The NPS wanted those driving, walking, or biking along the road to see and hear the "primitive isolation" experienced by the colonists. It took three years to complete the road, from 1955 through 1958. (Katherine Clark.)

The paintings were placed in pull-offs along the loop road. One of King's paintings of brick making, pictured here, illustrated how the settlers attempted to bring British construction techniques to the colony. The other subjects covered by the road signs included Colonial boatbuilding, soap making, ice harvesting, medical research, pottery, winemaking, Native American trading, tobacco, silk cultivation, furnishings, lumber, and coopering. (National Park Service, Colonial National Historical Park.)

THE ISTHMUS

This modern road crosses to Jamestown about on line with a natural isthmus which existed in Colonial times. The sandy strip that made Jamestown "a semi-island" was washed away in the 1700's.

When the three ships came up the James River and landed at Jamestown Island, it was truly not an island but an isthmus connected to what would become Glasshouse Point. The colonists would use that connection to explore the area and trade with the Native Americans. (Katherine Clark.)

The recreated isthmus shown here was built to allow motorists to reach Jamestown Island. When designers were planning the Colonial Parkway to Jamestown, they discussed two options. Either they would build a bridge from the eastern edge of the island or they would rebuild the isthmus and have the traffic follow the river around to Glasshouse Point. They chose to rebuild the isthmus so that visitors could enter the island from the mainland in the same way that colonists did. (National Park Service, Colonial National Historical Park.)

JAMESTOWN

Across the swamp lies Jamestown Island. Powhatan Creek below you, takes its name from the Indian Chief. To the right is Glasshouse Point, place of early glassmaking and later a part of the suburb of "James Cittie".

The colonists chose Jamestown Island for its defensibility. More than attacks by native peoples, they feared assaults by explorers from other European nations, particularly Spain. (Katherine Clark.)

The colonists survived long winters, and by 1609, other settlements began spreading along the James River. They learned how to plant tobacco from the Native Americans and developed crops that could be sold in Europe. Their financial success attracted more people to the New World. Jamestown Island was the center of the world the settlers knew until the government was moved to Middle Plantation (Williamsburg) in 1699. (National Park Service, Colonial National Historical Park.)

NECK OF LAND
near "James Citty"

This area, like a peninsula and bounded on three sides by marsh, is just across Back River from Jamestown Island. In 1625 there were a number of houses and 25 persons were living here. The settlement had close community ties to "James Citty" and sent representatives to the General Assembly there.

By 1625, Neck of Land was considered a suburb of Jamestown and had over 100 people living in the area at one time. Some 750 acres were owned by Rev. Richard Buck, the pastor of Jamestown. Beginning in January 1619, Buck and members of his family lived here for many years. The clergyman and his wife had six children, and the land passed to them after his death. (Katherine Clark.)

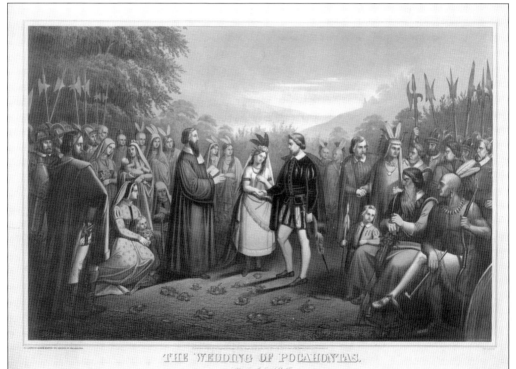

THE WEDDING OF POCAHONTAS.
With John Rolf.

The Reverend Richard Buck had a strong influence in the community. He was instrumental in helping to establish the peace between Powhatan's tribes and the English when he presided over the 1614 wedding of colonist John Rolfe and Pocahontas, daughter of Chief Powhatan, commemorated here in an etching. He also gave the invocation at the first meeting of the Virginia General Assembly in 1619. (LOC.)

REAL ESTATE

Early records tell of a land sale in 1636 being these 500 acres with "all howses… gardens, orchards, tenements." The property passed from Thomas Crompe "of the Neck of Land" to Gershon Buck son of the Reverend Richard Buck who ministered for more than a decade at Jamestown.

Colonists moved away from the Jamestown fort and onto their own land as more and more people arrived in Virginia. By 1636, some of those who had arrived in the beginning were selling their acreages to newcomers and moving farther inland. (Katherine Clark.)

Settlers built houses not only of wood but also of brick. Ships brought furniture, clothing, and other items to fill these homes. The community was thriving. (CWF.)

JAMESTOWN ISLAND

The woodland and marsh beyond the water is Jamestown Island, a pear-shape area of some 1,500 acres, being about 2 1/2 miles in length. It is separated from the mainland by Back Creek. In more recent times the wide mouth of this creek, which you see here, has been called the Thorofare.

The men who came to Jamestown had been told to sail "so far up as a bark of 50 tons will float." Native Americans had not previously found the small island in the James River to be habitable, but English colonists chose the site for its natural water barrier on three sides, which provided some protection from hostile attack. Not until they began to move to the mainland could the Jamestown setters find reliable sources of fresh water. (Katherine Clark.)

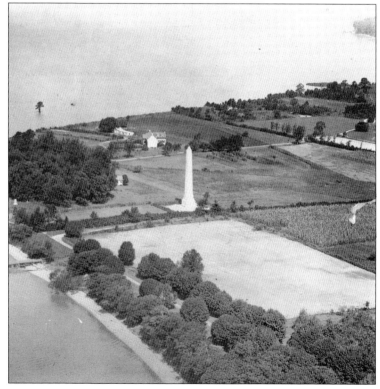

Though the island did provide them with relative safety, the first settlers were not prepared for the weather, the hostilities that developed with Native Americans, or the lack of food. Not until they began to move to the mainland could the Jamestown settlers find fresh water and tillable soil. (U.S. Navy.)

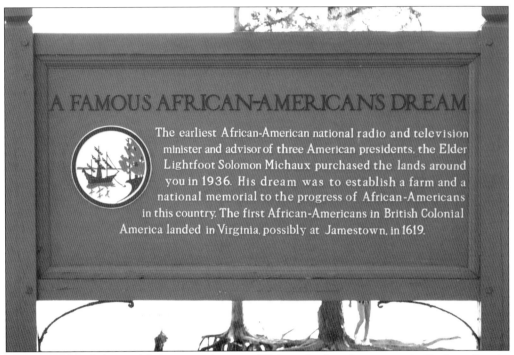

A FAMOUS AFRICAN-AMERICAN'S DREAM

The earliest African-American national radio and television minister and advisor of three American presidents, the Elder Lightfoot Solomon Michaux purchased the lands around you in 1936. His dream was to establish a farm and a national memorial to the progress of African-Americans in this country. The first African-Americans in British Colonial America landed in Virginia, possibly at Jamestown, in 1619.

Elder Lightfoot Solomon Michaux was born in 1884 not far from Jamestown in Buckroe Beach, Virginia. He grew up in the area and came to prominence with his radio show broadcast from Washington, D.C. At one point, his radio show had 25 million listeners. He later appeared on television as well. (Katherine Clark.)

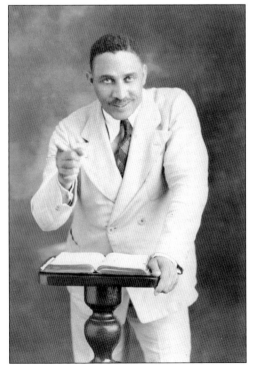

Michaux formed the Church of Gospel Spreading Association in 1919. His vision was to create a "National Memorial to the Progress of the Colored Race in America" in the James River area where African American families could enjoy recreation, education, and fellowship. After purchasing land along the James River, he founded the James City County Bible and Agriculture Training School Farm, which trained young African American men who had gotten into trouble. Though the parkway cut through Michaux's lands, the association still owned the property. In 1978, the Gospel Spreading Church finally sold about 10.5 acres to the NPS (stretching from the river to the road), with the provision that it could still use the land for another 15 years. (*Daily Press.*)

This photograph shows the grounds of the National Memorial in the 1950s. Michaux's original vision was to create a National Memorial along the James River with an administration building; a statue-filled African American Hall of Fame; a convention hall to host concerts, lectures, and music festivals; a college; church; and library. He also envisioned a pavilion, yacht basin, recreational beach, and picnic area. By the time the NPS took over the land in 1978, it held an amusement park, pier, fast food stand, unpaved parking lot, vacant restaurant, and several empty buildings. Although Michaux did not complete his dream for a National Memorial, he left a lasting legacy with the Gospel Spreading Church. (National Park Service, Colonial National Historical Park.)

GLEBE LAND

After 1619 these 100 acres of land were set aside for the benefit of the Jamestown parish church and minister. Richard Buck was the first clergyman to have use of it. Later on Francis Bolton became minister at "James Citty" and he, too, had "leave to make a lease of the Gleabe land neere unto Archers Hope."

The Glebe was a tract of land that would serve as the home farm for the current pastor for Jamestown. Chaplain Robert Hunt, who came over with the first colonists, did not live to use the land. Rev. Richard Buck moved onto the land when he arrived with his wife and family. The role of the pastor was to convert the Native Americans to Christianity and "keep the colonists in the spirit of God." Below is the remnant of the church that was built on Jamestown Island in approximately 1690, replacing the previous church burned during Bacon's Rebellion. (Katherine Clark/National Park Service, Colonial National Historical Park.)

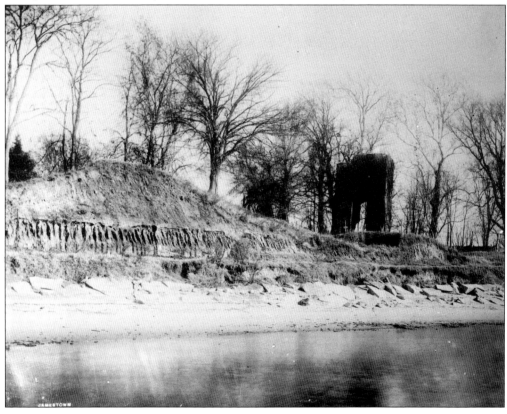

ARCHER'S HOPE

The great Indian massacre of March 22, 1622, during which a quarter of the population of Virginia was slain came nearest to Jamestown here in a community known as Archer's Hope. At the house of Ensign William Spence five persons were killed -- John Fowler, William Richmond, Alexander Bale, William Fairfax and "the Tinker."

During the uprising, members of the Powhatan Confederacy killed over 300 men, women, and children in the outlying areas, but the people at the fort in Jamestown received advance warning and were able to defend themselves. Powhatan chief Opechancanough had expected the surviving colonists to flee after the attack, but they retaliated instead. Then they built more fortifications at what would become Middle Plantation—later called Williamsburg—to strengthen their hold on the land. (Katherine Clark.)

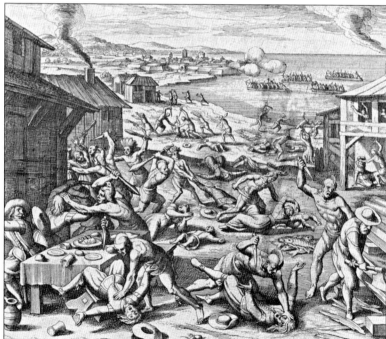

This woodcut was made by Matthaeus Merian in 1628 to depict the uprising that had occurred six years earlier. He followed the drawings of Theodore de Bry to show how the Native Americans looked. The engraving is considered speculative. (LOC.)

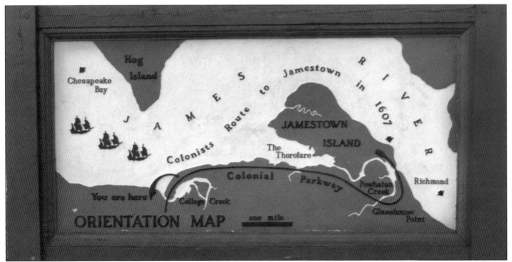

This orientation marker, located at the first pull-off at College Creek, shows the path the three English ships took coming up the James River to Jamestown Island. Motorists viewing the etching simply have to lift up their eyes to the river to visualize the ships coming past them at that very spot. (Katherine Clark.)

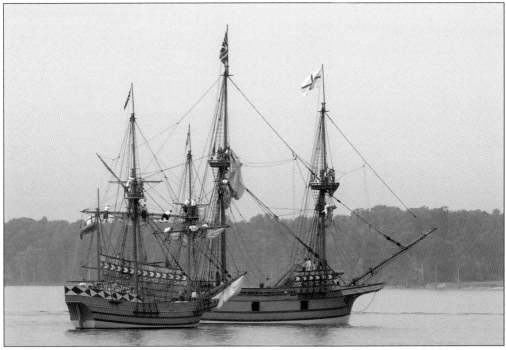

The three ships that brought the colonists to what became Virginia were the *Susan Constant*, *Godspeed*, and the *Discovery*, which sailed with a combined 104 passengers into Chesapeake Bay, up the James River, and past its tributaries. The ships had traveled 60 miles from Chesapeake Bay when the colonists' leader chose the island as the best place to settle. The replica ships seen here are displayed at Jamestown Festival Park, which opened in 1957 to commemorate the 350th anniversary of Jamestown's founding. Jamestown Festival Park is now called Jamestown Settlement. (Frances Clark.)

JAMES RIVER

Indians knew this as the Powhatan River, the colonists renamed it in honor of their sovereign, James I. It is one of Virginia's longest and broadest rivers. Rising in the Appalachians it flows eastward, often soil laden, 340 miles to the Chesapeake Bay. Its mouth is the world famous Hampton Roads.

The James River begins at the confluence of the Cowpasture and Jackson Rivers of northwestern Virginia. Spanish explorers preceded the British colony by nearly a century; they had named the river Rio del Espirita Santo (River of the Holy Spirit). (Katherine Clark.)

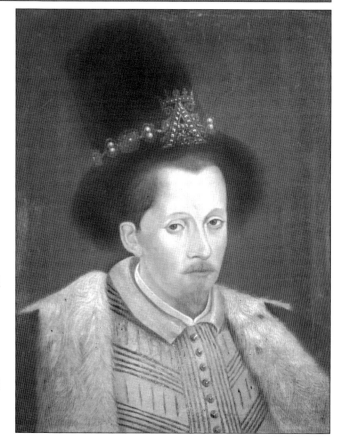

The James River served as a waterway for colonists and Native Americans of the area to fish, travel to other villages, and meet to trade with each other. The English named the river in honor of their king. Before James Charles Stuart became King James I of England and Ireland, he was crowned James IV of Scotland in 1567, when he was just 13 months old. In 1589, the now-grown king of Scotland married Anne of Denmark. The royal court painter, Adrian Vanson, created this portrait to commemorate the marriage. (Jamestown-Yorktown Foundation.)

ATTEMPTED SETTLEMENT

A small group of Spanish Jesuits attempted a settlement in Virginia in September, 1570. They are said to have entered James River and landed along this creek and crossed the peninsula to establish a mission near York River. Six months later all were massacred by the Indians save for one young boy. He was rescued by a relief expedition in 1572.

A party of Spanish Jesuits arrived in the area on September 10, 1570, to found a mission for evangelizing the native peoples of the region. Their interpreter was a teenaged Native American who had been taken prisoner by Spanish explorers 10 years earlier in order to learn his language. Soon after their arrival in Virginia, Don Luis deserted the others and rejoined his family. The others in the party—two priests, two catechists, two Jesuit brothers, and a Cuban boy named Alonzo de Olmos—attempted to persuade Don Luis to rejoin them, but instead, he and a group of other Native Americans robbed and killed everyone in the camp, with the exception of the young de Olmos. Two years later, an expedition led by the Spanish governor of Cuba sailed up the James River, rescued Olmos, and killed a number of Native Americans. Afterwards, the Spanish sailed southward, and Spain's dreams of colonizing modern-day Virginia sailed with them. (Katherine Clark.)

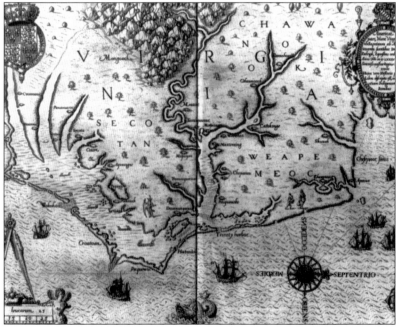

In the late 1500s, Spanish exploration was expanding not only in the southern hemisphere but in North America as well. This map shows the Spanish interpretation of what the Americas looked like. (LOC.)

COLLEGE CREEK

On May 12, 1607 the colonists who were the next day to establish Jamestown, landed at the mouth of this creek. Captain Gabriel Archer, one of the councilors, liked the spot and would have settled here but was outvoted. For more than a century the creek was known as Archer's Hope and later was named for the College of William and Mary.

As the Colonial Parkway turns towards Jamestown from Williamsburg, it follows along the James River. College Creek was originally called Archer's Hope Creek after Gabriel Archer who had helped make the decision to land in Jamestown. In 1705, the General Assembly of Virginia changed the name to Princess Creek. (Katherine Clark.)

Here the parkway's dirt surface is prepared for the concrete surface. The name of Princess Creek was changed to College Creek due to its proximity to the College of William and Mary. (National Park Service, Colonial National Historical Park.)

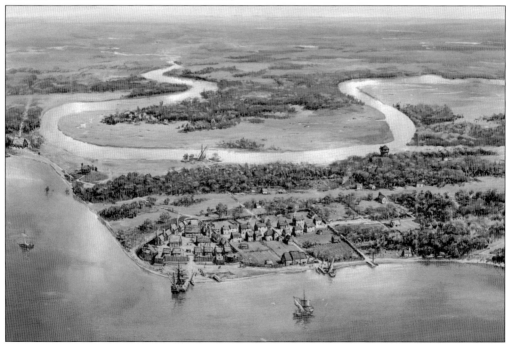

GREAT NECK

When Richard Brewster, gentleman, patented some 500 acres in this area on February 6, 1637 it was described as "the great Neck alias the barren neck." Cleared land then, the forest has since grown back.

The town of Middle Plantation, which would become Williamsburg, was seeing more and more growth. Gentlemen like Richard Brewster were acquiring land to establish homes and farms. Another massacre took place in 1644, but unlike the 1622 massacre, which had killed a fourth of the British settlers in Virginia, the later massacre (though it killed more colonists than the first one), had less impact on the growing colony. It was dealt with harshly, however. Opechancanough, chief of the Powhatan nation, was captured, and afterwards, shot by a guard. (National Park Service, Colonial National Historical Park.)

Six

THE WILLIAMSBURG MARKERS

The Williamsburg Area interpretive markers include the circular design showing the Colonial capitol building in the background with a town crier ringing a bell as he announces news of the day. Williamsburg became the Colonial capital in 1699 as the colonists moved inland and established a number of communities in the area. A proper capitol building—the first capitol erected in the British colonies—was constructed in 1705. The building suffered damage from fire in 1747. In 1780, the capital of Virginia moved to Richmond and the former capitol building fell into disrepair. (Katherine Clark.)

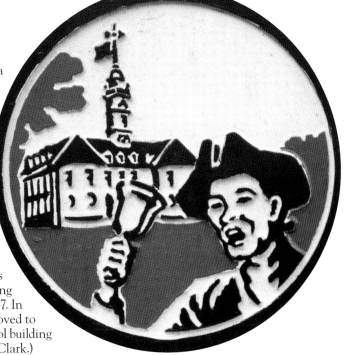

MILL DAM

The mound of earth in front of you was probably part of the dam for William Parks' paper mill. His mill was the first in Virginia for making paper and operated six years or more beginning 1744. Parks established the first permanent press in Virginia at Williamsburg. His paper mill supplied other printers, too, including Benjamin Franklin in Philadelphia.

William Parks's establishment was located on Duke of Gloucester Street in the Colonial capital. It was a place to hear the latest news, buy books and stationary, and post a letter. During this period, about 1,500 people lived in the capital. (Katherine Clark.)

Papetterie, Cave a Ouvrer.

This etching shows a paper mill similar to the one located near the dam off of the parkway. When William Parks set up his mill in 1743, he was assisted by a well-known Philadelphia printer, Benjamin Franklin. Paper was made manually, using linen rags from England until mills in the colonies could supply the rags. Though Franklin worked with Parks, he did not visit Williamsburg until 1756, after Parks's death. Franklin worked with the town's new publisher, William Hunter, to establish postal service for the colonies. (CWF.)

84

GREAT OAKS

These oaks were sprouting acorns about 1750 and were growing toward fair size during the time of Washington, Jefferson, Wythe and Marshall.

They are white oaks (Quercus alba) with a height near 90 feet and a spread together of some 150 feet.

The great oaks located between the Henry Street ramp and Route 199 on the parkway stood until the last fell in 2006. They survived the Civil War. (Katherine Clark.)

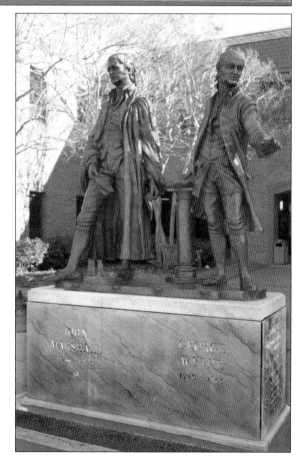

Such prominent men as George Washington, Thomas Jefferson, George Wythe, and John Marshall visited Williamsburg while these trees were growing and developing. George Wythe and John Marshall, shown here in a statue on the campus of William and Mary, were extremely influential in the new government and in American education. The law school is named for these two men. Wythe was the first law professor in the country. John Marshall studied law under Wythe and became the fourth chief justice of the United States, appointed by Pres. John Adams. (Katherine Clark.)

THE PALISADES

For protection against the Indians, the settlers built a log palisade across the narrows of the peninsula between the York and James rivers. This was about 1633. Middle Plantation (later Williamsburg) began as a settlement along this palisade which had its southern anchor where Paper Mill and College creeks join a half mile downstream.

The palisades were built after the 1622 uprising when security became extremely important to the colonists. Completed in 1634, the fortifications stretched six miles across the peninsula, from the James River to the York River. Settlers began building homes nearby and created a village called Middle Plantation. (Katherine Clark.)

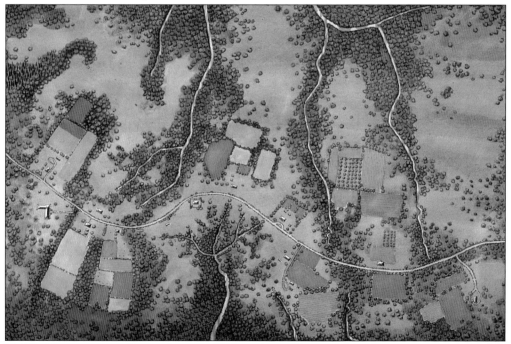

Middle Plantation would soon become Williamsburg. Heartened by the river-to-river palisade, a number of men built or bought homes in the area around 1633. The rendering here shows the road system of the time. More and more, colonists started to look at moving to Williamsburg both for the safety and the social opportunities it offered. (CWF.)

A UNION ADVANCE

On May 5, 1862 Lt. George A Custer (who in 1876 made his "Last Stand" on the Little Bighorn River in Montana) led a detachment along the road-way here over "Cub Dam Creek" to occupy the Confederate work on the bluff immediately beyond. This maneuver in the Battle of Williamsburg came as the Union Army advanced to-ward Richmond in the Peninsular Campaign.

One Union officer engaged at the Battle of Williamsburg was an ambitious lieutenant named George Armstrong Custer. Just 14 months after the Battle of Williamsburg, in the summer of 1863, he became the youngest brigadier general in the Union army. (Katherine Clark.)

Custer is pictured here with his dog near Williamsburg, where he distinguished himself in battle. After occupying the town, the Federals placed wounded Confederates in the barns and homes of town residents. One of the injured Southerners was Custer's former classmate from West Point, Capt. Willis Lea of the Fifth North Carolina Infantry. Custer arranged for him to recuperate at Bassett Hall, the home of Confederate colonel Goodrich Durfey. There he met and fell in love with Durfey's 17-year-old daughter, Margaret. They decided to marry. Though Lea was a Federal prisoner and had been moved to Fort Monroe, he returned to wed her at Bassett Hall in August. Custer arrived in time to stand up for his classmate and join in the wedding festivities. (LOC.)

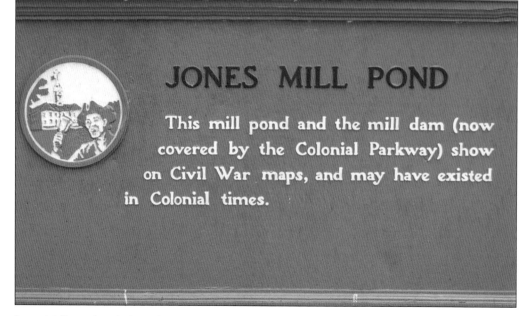

JONES MILL POND

This mill pond and the mill dam (now covered by the Colonial Parkway) show on Civil War maps, and may have existed in Colonial times.

Jones Mill Pond includes a dam that was the site of a battle on May 5, 1862. The property that at one time was owned by Ismail Jones was partially covered when the parkway was built. The Jones Mill Pond Dam located along the ridge had a culvert built during the road installation between 1931 and 1932. This culvert was built to serve two purposes: stabilize the dam and control the water overflow from the pond to the creek. The culvert was covered in the handmade brick with keystones made of Indiana limestone. (National Park Service, Colonial National Historical Park.)

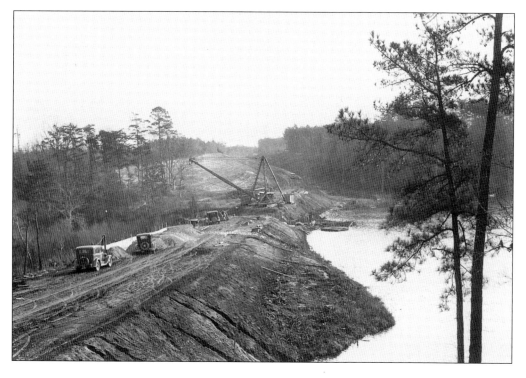

Seven

THE YORKTOWN MARKERS

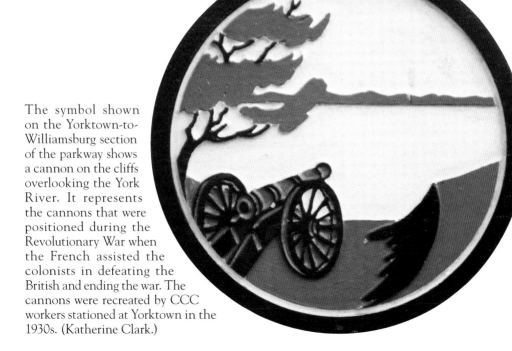

The symbol shown on the Yorktown-to-Williamsburg section of the parkway shows a cannon on the cliffs overlooking the York River. It represents the cannons that were positioned during the Revolutionary War when the French assisted the colonists in defeating the British and ending the war. The cannons were recreated by CCC workers stationed at Yorktown in the 1930s. (Katherine Clark.)

RINGFIELD PLANTATION

The land across this creek was first granted to Captain Robert Felgate in 1630. Sixty years later it was acquired by Joseph Ring, a prosperous planter and one of the trustees of the Town of York when it was founded in 1691. Ring's plantation house stood for over two centuries approximately one mile to the west.

Ringfield Plantation was located on Kings Creek near the parkway. The property it was built on had been in the Felgate family since Robert Felgate patented it in 1630. Eventually it came into the hands of Joseph Ring. Ringfield House, built in the late 17th century, was fashioned as an English-style home with "a long avenue of cedar trees." (Katherine Clark.)

Over time, Ringfield Plantation was owned by a number of families. When Landon Carter was owner, it was known as "Landowne." In 1920, the house came into the possession of D. L. Flory. On April 30, 1920, he sold it to the government to be used as the residence of the first inspector of ordnance in charge of the Naval Weapons Station. However, the house burned down that December. (National Park Service, Colonial National Historical Park.)

The land shown here was a large part of the Glebe holdings of old Hampton Parish. For many years after the parkway was built, this spot served as the Ringfield Picnic Area. In the summer of 1970, more than 330,000 people used one or more of the parkway's three picnic areas at Yorktown Beach, Ringfield Plantation, and Great Neck. (National Park Service, Colonial National Historical Park.)

NATHANIEL BACON

Among the tombs in the burial ground of the Ringfield family is a marker to Colonel Nathaniel Bacon who was prominent in Virginia affairs in the last half of the seventeenth century. He was a kinsman but an opponent of Nathaniel Bacon, Jr. – "the Rebel" – who led his forces against Governor Sir William Berkeley in 1676.

Nathaniel Bacon, remembered on this marker, was the uncle of the man who began Bacon's Rebellion. Nathaniel did not support his nephew's beliefs but served as president of the honorable council of Virginia and as York County commander in chief. Born in 1620, by the time of his death in 1692, Bacon had served on the local council for over 40 years. He was buried near Ringfield. (Katherine Clark.)

The peninsula where Ringfield Estate stood was across the water from the markers for Ringfield and Nathaniel Bacon. The tombstone of Bacon's wife, Elizabeth Kingsmill Bacon, was found on the west side of Kings Creek and moved to St. Paul's Church in Norfolk, Virginia; his was found in a field near Glebe Landing Road and moved to the Ringfield burial ground. (Katherine Clark.)

CHEATHAM ANNEX

The piers and structures across the water are an extension of the Naval Base at Norfolk. This takes advantage of the excellent York River deep water channel as did Cornwallis when, in 1781, he chose Yorktown as his base.

Before the Cheatham Annex was established, DuPont had a mine depot facility. During World War I, it served to produce mines and explosives. Many of the men that worked there lived with their families in a town called Penniman, which was next to the facility. Penniman was named after Russell S. Penniman, inventor of ammonia dynamite. When the U.S. Navy took over the facility, they expanded it, and many of the families in the area had to move. (Katherine Clark.)

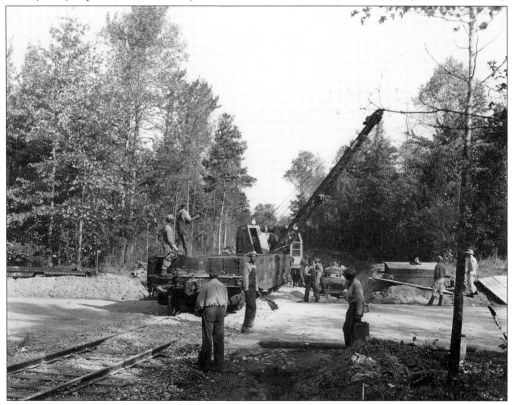

The construction of the parkway came through parts of the Cheatham Annex and required the creation of a security checkpoint now that drivers could access the road to the facility. The overpass that the parkway used over Penniman would be built just as the others were; however, cold weather and rain cased delays. Once completed, it allowed motorists to continue their drive to Williamsburg unimpeded. (National Park Service, Colonial National Historical Park.)

BELLFIELD PLANTATION

The Bellfield house site and graveyard are located some 300 yards to the east. This was the home of two early Virginia governors, Captain John West in 1632 and Edward Digges who bought the property from West in 1650. Here Digges produced superior tobacco and led attempts to develop silk culture in the colony.

Stately Bellfield Plantation was located along the York River, which in the first years of British colonization was considered the raw American frontier. As such, colonists were given tracts of land as incentives to settle along the York. John West served as Virginia's governor from 1635 to 1637. His son, John West Jr., born here in 1633, was the first English child born at a home on the York River. John West Sr. would go on to establish several other plantations. Edward Digges, who purchased the house in 1650, served as a Commonwealth of England governor from 1655 to 1656. (Katherine Clark.)

In 1934, before the parkway was completed, the CCC performed archeological excavations at Bellfield Plantation. Edward Digges had attempted to raise silk worms commercially, using a number of mulberry trees to keep them. He was not successful. He later became the agent who coordinated the sale of tobacco to the British back home. Edward Digges served as governor of Virginia from 1655 to 1656. (National Park Service, Colonial National Historical Park.)

INDIAN FIELD CREEK

The ground to the south along this creek was the home of the Chiskiack Indians, a small tribe whose leader was a "werowance," or petty chief, under Powhatan. As the English began to settle this area, about 1630, the Chiskiacks moved across the York River into the present Gloucester County.

Indian Field Creek is located off the York River. This area was once home to the Chisiack Indians. They were part of the Powhatan Nation and had settled on the York River. Because they were further away than other tribes, they did not interact at first with the colonists. They did, however, participate in the 1622 uprising. (Katherine Clark.)

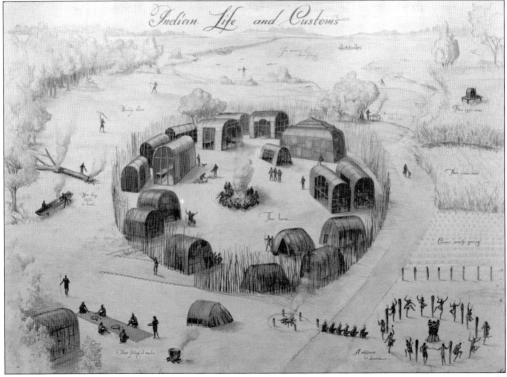

By 1649, the Chisiack Indians had moved to the Piankatank River. They eventually settled in what is now Gloucester County, across the river from where they had originally lived. Within 20 years, the Chisiacks had so few members that they dissolved to join other tribes. Shown here is a typical Chisiack village of the 1600s. (National Park Service, Colonial National Historical Park.)

POWHATAN'S VILLAGE

Across the York River is the site of Werowocomoco, an Indian village that was Powhatan's "chiefest habitation" in the early period of the Jamestown settlement. Captain John Smith was a prisoner there late in 1607.

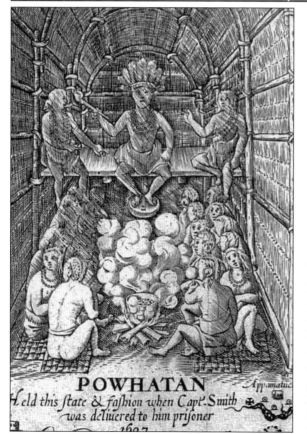

POWHATAN

Held this state & fashion when Capt. Smith was deliuered to him prisoner 1607

Chief Powhatan's village, while located on the north side of the York River, was the center of a strong group of tribes that resided in the Tidewater area. The Powhatan nation was made up of more than 21,000 members from 30 tribes when the first settlers came to Jamestown. (Katherine Clark.)

The daughter of Chief Powhatan, Pocahontas, helped build a bond between the Native Americans and the colonists. With her marriage to John Rolfe, the two factions for a time lived together in harmony. However, in 1618 the chief died, and his brother Opechancanough took over. His goal was to chase the English out of Powhatan lands; the 1622 uprising of more than a third of Virginia's settlers was the result. (LOC.)

YORK RIVER

Known to the Indians as the Pamunkey, the colonists named it first Charles and then York, both in honor of the Duke of York. While only 26 miles in length, the tidal waters of the York River flow over the deepest natural channel of any Chesapeake Bay tributary.

The parkway parallels the York River from Yorktown until it turns at Cheatham Annex and Kings Creek and heads toward Williamsburg. In the early days of the Jamestown settlement, groups from the fort would explore this area. (Katherine Clark.)

When the colonists first came to the area, they referred to what is now the York River as the Pamunkey, named for a local Native American tribe. The name was changed in 1630 to the Charles River in honor of the Duke of York, pictured here. In 1642, it was changed again—this time to the York River. By then, James Stuart, the future King James II, was the Duke of York. He was the second son of King James I, for whom the James River was named. (LOC.)

97

NAVAL WEAPONS STATION

The piers extending into the York River, just to the right, serve a major Navy installation. Since its establishment in 1918, then as a Mine Depot, it has served our country in two World Wars and the Korean conflict as well as in peace time.

The Naval Weapons Station began as the DuPont Company. The company started with 4,000 acres on the York River. In 1918, the president allowed the property to be taken over by the navy through proclamation. The purpose was for mines to be stored and tested. They also were set up to train naval personnel. (Katherine Clark.)

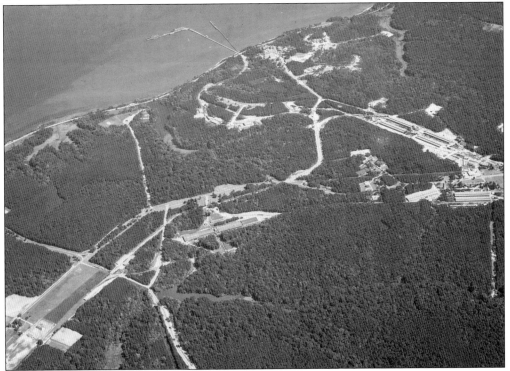

The aerial view of the Yorktown Naval Weapons Station shows the docks before they were completed. The Colonial Parkway can be seen here, following the shoreline of the York River on its way to Williamsburg. (U.S. Navy.)

FRENCH TRENCH

This earthwork was manned by the "Regiment Touraine" and formed the western portion of the French and American siege line surrounding Yorktown. From this line the French fired upon ships in the York River and the British fort behind you.

This was the site of a French fortification to help control the York River. Approximately 600 French soldiers and sailors died in the battles in 1781. French soldiers had been fighting since 1778. With the American and French forces in Gloucester and Yorktown, the British were eventually forced to surrender. (National Park Service, Colonial National Historical Park.)

Southwest of Fusiliers' Redoubt in Yorktown, overlooking the York River, sit two reproductions of cannons built for the bicentennial. These were the type of cannon used by the French and Americans to fight the British during the last days of the Revolutionary War. (Katherine Clark.)

FUSILIERS REDOUBT

Here, just west of Yorktown, the British built an earthwork to control the road to Williamsburg. This fortification was manned by the Royal Welch Fusiliers throughout the siege. The path leads to the reconstructed redoubt.

The British built this fortification to protect themselves and counter any attacks from the west of Yorktown. They were critical to the success of Cornwallis in defending his position. The redoubts were located across from the French Trench. (Katherine Clark.)

The Royal Welch Fusiliers who defended Yorktown's redoubts were created in 1689. They had been successful in fighting the 1713 War of Spanish Succession. They had fought in the Revolutionary War from the very beginning. The regiment later fought in World War I. (Katherine Clark.)

In the 1930s, the NPS laid out the Yorktown battlefield to allow self-guided tours. The fortifications below were part of the British inner defense line and are the original earthworks from 1781. (Katherine Clark.)

THE HORNWORK

To your right the British extended their works outward along the York-Hampton Road a principal entrance into Yorktown which they blocked with this "Hornwork." It was garrisoned by Colonel Abercrombie's Light Infantry.

Cornwallis and his men used redoubts, fortifications, and a hornwork—a wedge placed to make the main line of defense stronger. Cornwallis's men built a hornwork near the York Road, along with redoubts and gun batteries. (Katherine Clark.)

Eight

EVENTS, WILDLIFE, AND RECREATION ON THE PARKWAY

On May 15, 1953, Pres. Dwight D. and Mamie Eisenhower arrived in Yorktown to begin a tour of the area. The presidential yacht, *Williamsburg*, docked at the Yorktown Naval Weapons Station, where it was greeted by Capt. G. A. Massenburg, president of the Virginia Pilot Association. He also represented the College of William and Mary as a member of the college's Board of Visitors. President Eisenhower received an honorary degree from William and Mary and spoke at Colonial Williamsburg's 1953 Prelude to Independence ceremonies when he visited Williamsburg. (Will Molineux.)

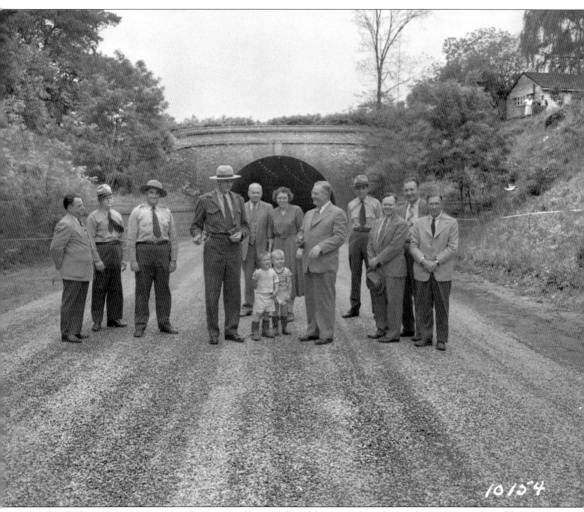

The Colonial Parkway tunnel was mostly completed by 1941, but due in large part to World War II, the tunnel remained unopened until 1949. At noon, May 10, 1949, Williamsburg mayor Dr. H. M. "Polly" Stryker cut the tape to commemorate the tunnel's opening. The celebration participants pictured here from left to right are Lloyd Haynes Williams, bureau manager for the *Daily Press* newspaper and also the vice mayor of Williamsburg; Charles Hatch, historian for the Colonial National Historical Park; unidentified National Park Service ranger; NPS superintendent E. A. Hummel; Donald Southworth, Winifred West Southworth, and their children; Mayor Stryker; another unidentified ranger; business administration professor and city council member Charles Marsh from the College of William and Mary; and two more unidentified persons. Given the many years of delays leading up to the tunnel's opening, NPS superintendent Hummel received some ribbing when it was discovered that the ceremonial ribbon was, in fact, made of bona fide government-issue red tape, used for binding documents together. (National Park Service, Colonial National Historical Park.)

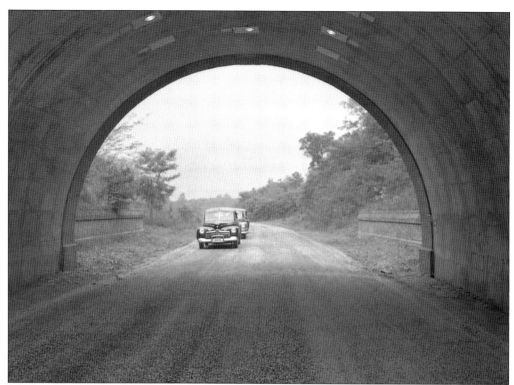

A 10-car motorcade followed the ribbon-cutting ceremony for the tunnel. It drove from the tunnel's north entrance through the newly lighted and paved interior, came out on the south end, and drove up the ramp to Williamsburg's Francis Street. (National Park Service, Colonial National Historical Park.)

Pictured here from left to right in front of the powder magazine are Hugh B. Rice, Williamsburg city manager; Dr. "Polly" Stryker, Williamsburg mayor; and A. Edwin Kendrew, senior vice president of Colonial Williamsburg. Dr. Stryker was a strong supporter of the restoration of Williamsburg as well as the development of the national historical park and parkway. He joined the city council as a young man in 1933 and rose to serve as mayor from 1948 to 1968. Edwin Kendrew began at Colonial Williamsburg in the architectural department. (City of Williamsburg.)

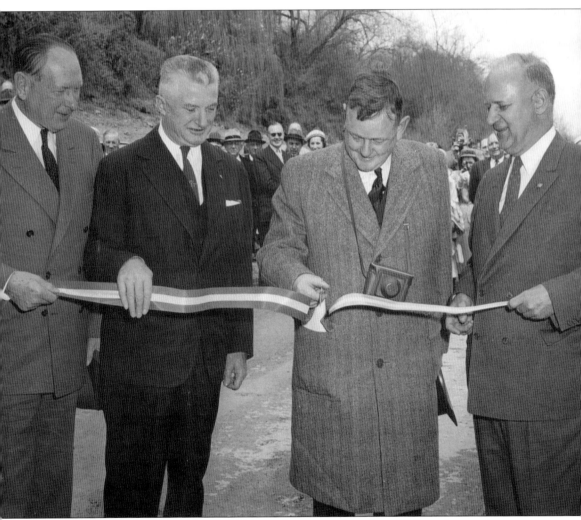

Construction for the unfinished part of the parkway stretching from Williamsburg to Jamestown began in August 1954 in order to be complete in time for the 350th anniversary celebration of the Jamestown landing. The parkway needed to be completed before the event, and after much hard work, it was. On April 1, 1957, the 26-year-long project was pronounced complete. The parkway reached from the Jamestown Visitor Center though Williamsburg and ended at the Yorktown Visitor Center parking lot. Seen here at the ribbon-cutting ceremony are, from left to right, Gov. Thomas B. Stanley, U.S. Assistant Secretary of Commerce Ferdinand Mueller, British Minister of Education Viscount Hailsham, and NPS director Conrad L. Wirth. Hailsham headed an English goodwill group from England. They rode to the ceremony on the newly completed parkway with a motorcade of the officials involved in the opening. (The *Daily Press*.)

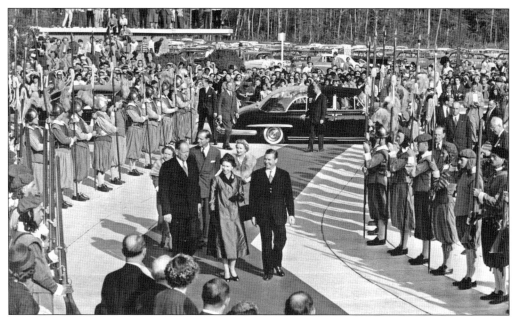

Queen Elizabeth II attended one of the events commemorating the Jamestown landing. She travelled to Jamestown via the Colonial Parkway in a bubble-top limousine sent for her use by President Eisenhower. As she walks past the Colonial Guards in this photograph, the car sits in the background. From left to right, accompanying the queen are (first row) Virginia governor Thomas B. Stanley, Queen Elizabeth, and U.S. Chief of Protocol Wiley T. Buchanan Jr.; (second row) Anne Pocahontas Basssett Stanley, Prince Philip, and Ruth Buchanan. (CWF.)

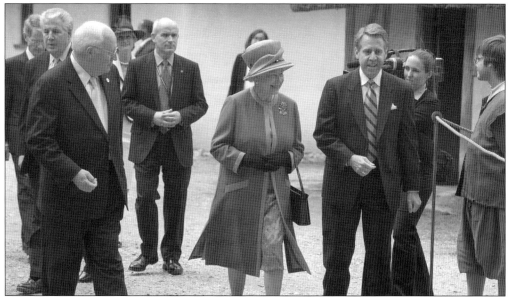

Fifty years later, Queen Elizabeth II returned for Jamestown's 400th anniversary. The Queen and Prince Philip arrived in Williamsburg and stayed at the Williamsburg Inn, just as they had in 1957. They also traveled again via the Colonial Parkway to visit Jamestown. The Queen is seen here with Vice Pres. Dick Cheney (left) and Jamestown-Yorktown Foundation executive director Phil Emerson (right). (CWF.)

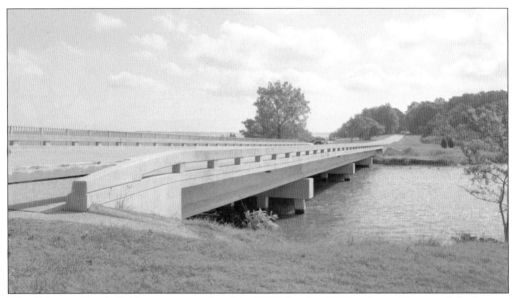

The Felgates Creek Bridge was completed in 1933. In the 1980s, the railings and deck were renovated and a bike crossing was added. In 1945, the president of William and Mary, John E. Promfret, wrote to NPS superintendent J. C. Harrington. He suggested that the NPS consider putting in a bike path when they completed the route from Williamsburg to Jamestown. Promfret felt that since the students at William and Mary were not allowed to have automobiles, a bike path would be especially beneficial. The idea was considered, but it never came to fruition. (National Park Service, Colonial National Historical Park.)

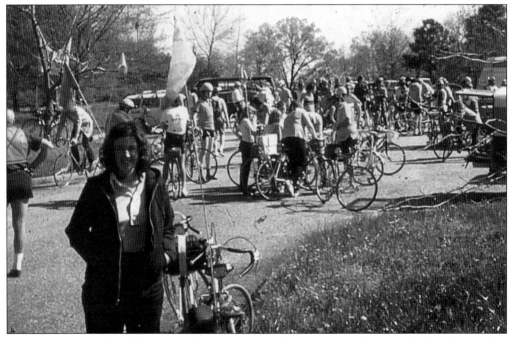

Even without a dedicated bike lane, the parkway has become a popular place for bicyclists. It has been site of a number of bicycle rides. Shown here is Sally H. Bolte, a participant in a April 20, 1975, parkway ride held by the Richmond Area Bicycle Association. (Steve Bolte.)

Since 1996, the Historic Triangle Bicycle Advisory Committee has hosted the "Pedal the Parkway" event on the Williamsburg to Jamestown leg of the Colonial Parkway. Every year, on the first Saturday in May, the NPS shuts down the parkway to motor traffic to offer a safe environment for bikers from around the region. Shown here are Allen and Mary Turnbull, riding a tandem bicycle on the isthmus toward Jamestown Island. In the background is the Jamestown-Scotland Ferry, which transports passengers and vehicles across the James River. (Tom Saunders, VDOT/Public Affairs.)

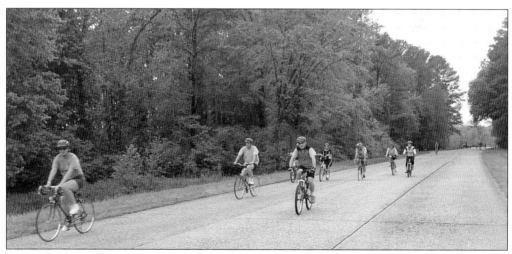

In this image, bicyclists ride along the 8 miles of vehicle-free parkway. Local businesses have supported the "Pedal the Parkway" event ever since it began. More than 1,000 people participate every year. (Allen and Mary Turnbull.)

The row of officers' houses was built in 1918 as part of the U.S. Navy Mine Depot. They looked out at the York River. When it was determined that the parkway would pass by the houses, the planners had to determine the best design to create as little disruption as possible for the residents. This was done by keeping the road area of the parkway as close to the shoreline and as far below the line of sight as possible. The homes continue to serve as houses for officers at the Yorktown Naval Weapons Station. (U.S. Navy.)

From Yorktown's sandy shore to College Creek on the James River, tourists and locals have enjoyed the beaches along the parkway since its opening day. (The *Daily Press*.)

The parkway served as a campaign trail in 1971 for Dr. George W. Grayson, a young professor at William and Mary College running for the Virginia House of Delegates. To show his concern for voters in the 97th District and his appreciation for nature, he walked from the Williamsburg-James City County Courthouse to the York County Courthouse via the Colonial Parkway. Though the walk was covered by the three local television stations, Grayson lost the 1971 contest. Two years later, however, he won—and spent the next 27 years in the legislature. (*Virginia Gazette.*)

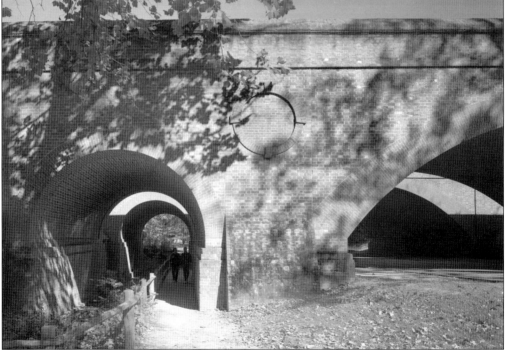

The Lafayette Street and C&O Railroad underpass includes an open pedestrian walk that leads visitors to the restored area. The path started at the Colonial Williamsburg Information Center directly off the parkway and took tourists on a path around the curve of the parkway as it went toward the north entrance of the tunnel. As they walked up the hill, the visitors would see Robertson's windmill in a field and thus begin their exploration of the area's Colonial homes and historic sites. The path is still used today. (National Park Service, Colonial National Historical Park.)

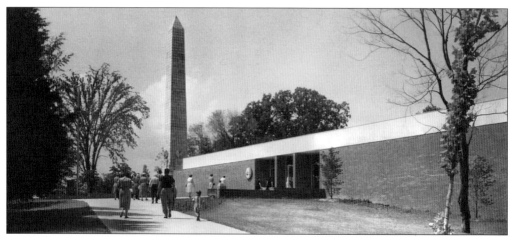

At the beginning of 1956, visitors to Jamestown Island found only a concrete-block exhibit and laboratory building. There were also poor sanitary facilities and insufficient parking. Yorktown was a little better; its visitor center occupied the historic Swan Tavern. It featured a number of exhibits, some housed in the stable behind the tavern, but Yorktown, too, suffered from insufficient parking. Certainly neither center could handle the number of tourists that were projected to attend the upcoming anniversary. The NPS developed plans to complete the parkway and build a new visitor center at each end. In March 1956, work began on the construction of the two centers. They were both built as two-story structures including offices, exhibit halls, and auditoriums. The Jamestown Visitor Center, pictured above, opened in December 1956, followed by the Yorktown Visitor Center, pictured below, which opened in February 1957. (National Park Service, Colonial National Historical Park.)

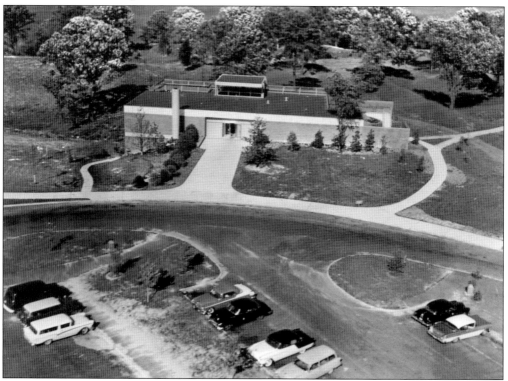

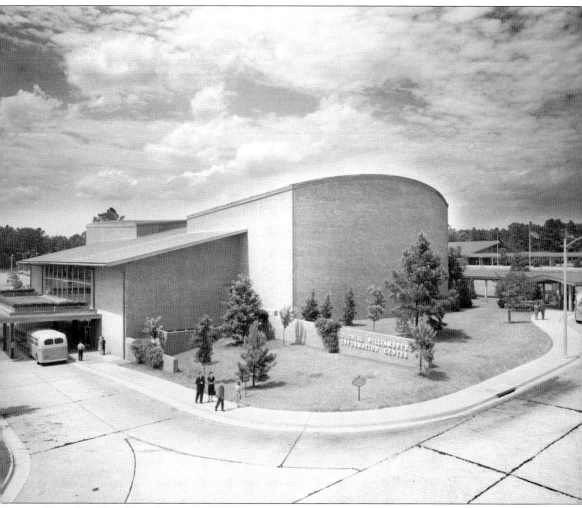

The Colonial Williamsburg Information Center, shown here, was located directly off the parkway, serving as the entry point for the Williamsburg Historic Area. The building site chosen was at the turn of the parkway just after travelers came out of the tunnel to continue their drive to Yorktown from Jamestown. The center opened on March 31, 1957. On that same day, the movie, *Story of a Patriot*, was first shown in the center's theater. The film has been entertaining and educating visitors ever since then and has been called the longest-running motion picture in history. In February 1984, the center's name officially changed to the Colonial Williamsburg Visitor Center. (CWF.)

During the 1940s, some of the sororities at William and Mary used the yet-unopened tunnel as a rainproof storage shelter for their paper-and-chicken-wire floats before the school's homecoming parade. This float, featured in the 1949 William and Mary *Echo*, was decorated by the Kappa Kappa Gamma sorority and is representative of the type of floats that would have been stored in the tunnel. (Jean Canoles Bruce.)

The parkway was always intended as a scenic drive, rather than as a commuter or high-traffic highway. Nonetheless, as more and more cars travelled along the road, accidents were inevitable. The car in the image above ended up on the railing due to excessive speed and weather. The three-car wreck pictured below happened on Labor Day 1953. Deer crossings, alcohol use, and speed are the largest cause of accidents along the parkway. (Williamsburg Fire Department.)

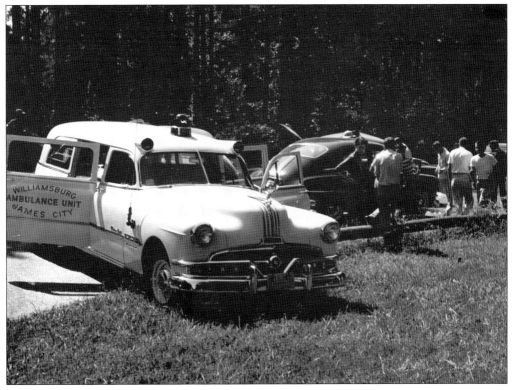

Raccoons are abundant in the Colonial Parkway area. When the colonists came to Jamestown, they would call familiar animals the same names they had used back in England. The colonists had never seen a raccoon before, so they turned to the name used by the local Native Americans, who called the animal something that sounded to English ears like "arocoun," "arakun," or "aroughcun." Capt. John Smith is credited with formalizing the spelling of the modern English term "raccoon." (Virginia Department of Game and Inland Fisheries.)

The bird migration path called the Atlantic Flyway passes through the coast of Virginia and includes the York and James Rivers, accounting for the many species of birds seen in the area. This crane is one example. (Virginia Department of Game and Inland Fisheries.)

The first British settlers noted that the area was heavily populated with bald eagles. As the area's human population increased, its eagle population decreased due to a reduced food supply. Today eagles—as well as vultures and osprey—nest in the area around the parkway. (Virginia Department of Game and Inland Fisheries.)

American red fox such as the one seen below abound along the parkway, but as nocturnal hunters, they are rarely seen during the day. Grey fox also live along the parkway but are mostly found on Jamestown Island. (Virginia Department of Game and Inland Fisheries.)

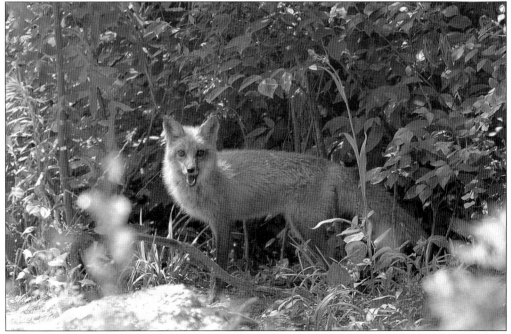

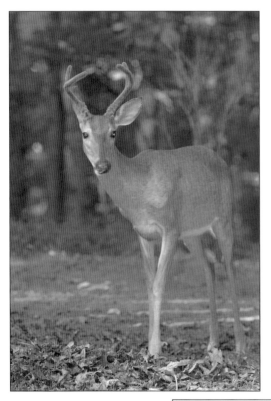

One of the most commonly seen animals on the parkway is the deer. The most unique deer, however, are found on Jamestown Island. Those deer are smaller than the average whitetail deer, and travel in groups. Not unlike the Key Deer found in Florida, they are able to survive due to an abundance of acorns and other food. (Virginia Department of Game and Inland Fisheries.)

Waterfowl are plentiful in the area on and between the two rivers; several hundred merganser ducks can often be spotted heading south at once. Other birds in the area include shorebirds, redheaded turkey vultures and the Canadian Geese seen in this photograph. These geese are on an embankment at the isthmus leading from Glasshouse Point to Jamestown Island. (Virginia Department of Game and Inland Fisheries.)

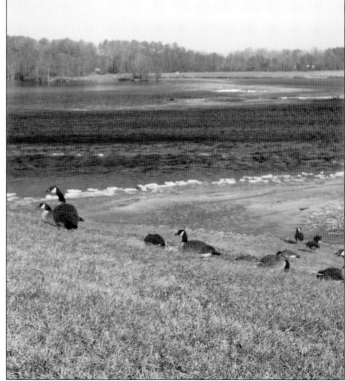

Shirley Temple, child actress of the 1930s and 1940s, came with her father, George F. Temple, to visit Williamsburg. While there, she celebrated her 10th birthday with some local children. She also traveled to Yorktown by the parkway and is shown here with Supt. B. Floyd Flickinger (on the right) and acting chief ranger Harry W. Doust. (National Park Service, Colonial National Historical Park.)

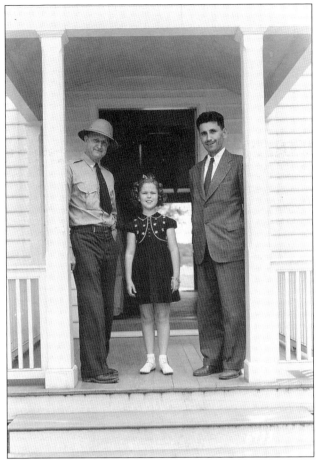

In 1975, Shirley Temple Black, at left, returned to Williamsburg and Yorktown 37 years later to escort the president of Finland, Dr. Urho Kekkonen, at her right. Black was the U.S. Ambassador to England and the U.S. Chief of Protocol. They visited the historic area and traveled from site to site. Many of the visitors that followed the group seemed more interested in seeing Shirley Temple than the president of Finland. (CWF.)

Storms have plagued the Colonial Parkway throughout its 75-year history. Pictured above is the devastating effect of Tropical Storm Ernesto, which hit the parkway in 2006, causing an estimated $118 million in damages statewide. On September 12, 1960, Hurricane Donna hit the area in the early morning with 50 to 60 mile-per-hour winds, causing considerable destruction on Jamestown Island. Other storms impacting the parkway included the delays in April 1940 caused with heavy snow and cold weather. Below is repair work to a washed out culvert caused by Tropical Storm Ernesto. (National Park Service, Colonial National Historical Park.)

Hurricane Isabel hit the Colonial Parkway on September 18, 2003, causing considerably more damage than Tropical Storm Ernesto. Besides scarping and erosion, Isabel toppled an estimated 10,000 trees along the parkway and closed portions of the park for months. Pictures here show some of the destruction that occurred. (National Park Service, Colonial National Historical Park.)

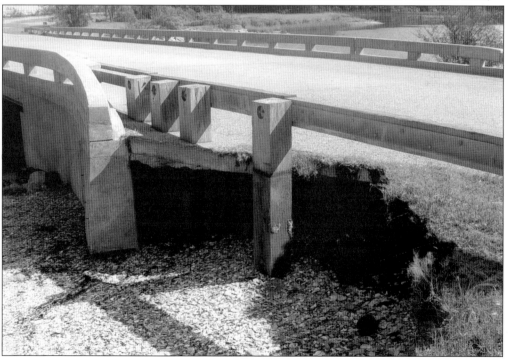

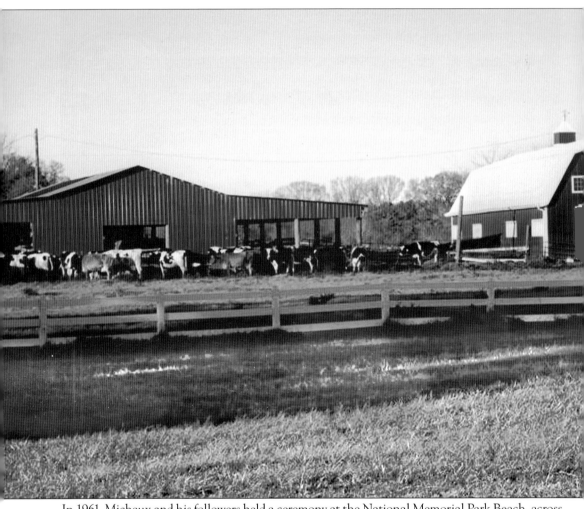

In 1961, Michaux and his followers held a ceremony at the National Memorial Park Beach, across from the farm above on the shore of the James River, commemorating the 100th anniversary of the last boatload of slaves that landed in the area. After Michaux's death, the farm that he founded to teach adults and children continued to do the work he supported. Today it serves as a working farm and can be seen from the parkway as tourists drive along the James River toward Jamestown. (Katherine Clark.)

In July 1936, Pres. Franklin D. Roosevelt returned for a second visit to the historic area. He was given a tour of the area and saw all of the work that had been done on the restoration. He is pictured here traveling through Williamsburg. (CWF.)

Pres. Ronald and Nancy Reagan attended the October 19, 1981, Yorktown bicentennial celebration. The president released Proclamation 4857, commemorating the American victory and proclaiming a public celebration of the British surrender. Reagan also came to Williamsburg during his visit for more celebrations. (CWF.)

The Yorktown celebration of the 200th anniversary of the Revolutionary War victory occurred October 16–19, 1981. Dignitaries, including the Virginia governor and President Reagan, attended the events. Seen here from left to right in one of the carriages that travelled the parkway are Gov. John Dalton of Virginia; an unidentified person; Bill Brown (a historian with the NPS); and two more unidentified people. The coachman on the back is Willie Fitts of the Colonial Williamsburg Coach and Livestock division. (CWF.)

Tradition has always been a strong part of the Colonial Williamsburg Fifes and Drums. During the Revolution, the American army recruited boys from age 10 to 18 to serve as field musicians. In 1958, Colonial Williamsburg established the Field Music of the Virginia State Garrison Regiment for performances. Later they opened the group to boys and girls from 10 to 18. They perform 18th-century music and serve as role models around the country. The Colonial Williamsburg Fifes and Drums Regiment is shown here on October 19, 1981, participating in the 200th anniversary of the British surrender by marching down the parkway from Williamsburg to Yorktown. (CWF.)

The Old Guard Fife and Drum Corps of the U.S. Army participated in the 200th anniversary of the American victory at Yorktown in October 1981. As part of the 3rd U.S. Infantry Regiment, the corps marched with other participants from Williamsburg to Yorktown via the Colonial Parkway. Created in 1960, the 69-member corps wears Colonial-style uniforms with tricornered hats, white wigs, and red coats. They are shown here at the far right following the Williamsburg Fifes and Drums Corps and Colonial interpreters past the Jones Mill pull-off. (CWF.)

Since the mid-1930s, tourists, residents, and history lovers have traveled the Colonial Parkway, a 23-mile road that carries motorists through 174 years of history. (National Park Service, Colonial National Historical Park.)

BIBLIOGRAPHY

Cultural Landscape Report for the Colonial Parkway, Part 1. Landscape Contract No. 1443C400095038, Principal: Patricia O'Donnell, U.S. Department of the Interior, National Park Service, Colonial National Historical Park; Chesapeake and Allegheny Systems Office, November, 1977.

Gonzales, Donald J. *Rockefellers at Williamsburg: Backstage with the Founders, Restorers, and World-Renowned Guests.* McLean, VA: EPM Publications, 1991.

Haile, Edward W., ed. *Jamestown Narratives: Eyewitness Accounts of the Virginia Colony, the First Decade, 1607–1617.* Champlain, VA: RoundHouse, 1998.

Harllee, Ella F. *The Story of Richard Bucke Chaplin of the First General Assembly of Virginia.* Washington, D.C.: Educational Communication Association National Building, 1977.

Hatch, Charles E., Jr. *Colonial National Historical Park: Ringfield Plantation.* Office of History and Historic Architecture, Eastern Services Center. September, 1970.

Jamestown-Williamsburg-Yorktown Celebration Commission. *The 350th Anniversary of Jamestown: 1607–1957. Final Report to the President and Congress of the Jamestown-Williamsburg-Yorktown Celebration Commission,* 1958.

McDonald, Bradley M., Kenneth E. Stuck, and Kathleen J. Bragdon. *"Cast Down Your Bucket Where You Are": An Ethnohistorical Study of the African American Community on the Lands of the Yorktown Naval Weapons Station, 1865–1918.* Rep. Williamsburg: William and Mary Center for Archaeological Research, Department of Anthropology at the College of William and Mary, 1992.

Montgomery, Dennis. *A Link Among the Days; the Life and Times of the Rev. Dr. W. A. R. Goodwin, the Father of Colonial Williamsburg.* Null: Dietz Press, 1998.

Morgan, Timothy E. *Williamsburg: A City that History Made.* Charleston, SC: Arcadia Publishing, 2004.

National Register of Historic Places: Colonial Parkway, NPS Form 10-900, U.S. Department of the Interior, National Park Service, submitted.

Rountree, Helen C. *Beyond The Village: A Colonial Parkway Guide to the Local Indians' use of Natural Resources.*

Rouse, Parke Jr. *Cows on the Campus.* New York: Dietz, 1987.

———. *Remembering Williamsburg.* New York: Dietz, 1989. Print.

RELATED INTERNET SITES

Williamsburg Area Bicyclists: www.wabonline.org
Richmond Bicycle Association: www.raba.org
Virginia Department of Game and Inland Fisheries: www.dgif.virginia.gov
U.S. Army Old Guard: www.army.mil/fifeanddrum
National Park Service: www.nps.gov/colo
Colonial Williamsburg Foundation: www.history.org

www.arcadiapublishing.com

Discover books about the town where you grew up, the cities where your friends and families live, the town where your parents met, or even that retirement spot you've been dreaming about. Our Web site provides history lovers with exclusive deals, advanced notification about new titles, e-mail alerts of author events, and much more.

MADE IN THE USA

Arcadia Publishing, the leading local history publisher in the United States, is committed to making history accessible and meaningful through publishing books that celebrate and preserve the heritage of America's people and places. Consistent with our mission to preserve history on a local level, this book was printed in South Carolina on American-made paper and manufactured entirely in the United States.

This book carries the accredited Forest Stewardship Council (FSC) label and is printed on 100 percent FSC-certified paper. Products carrying the FSC label are independently certified to assure consumers that they come from forests that are managed to meet the social, economic, and ecological needs of present and future generations.

FSC
Mixed Sources
Product group from well-managed forests and other controlled sources

Cert no. SW-COC-001530
www.fsc.org
© 1996 Forest Stewardship Council

Find Your Place in History.